IMAGES
of America

ALCOA

To Joanne:
 I hope you enjoy our
story of Alcoa, and that it
brings to mind happy memories
of good times spent here.
 Best wishes,
 David R. Duggan

Thank you

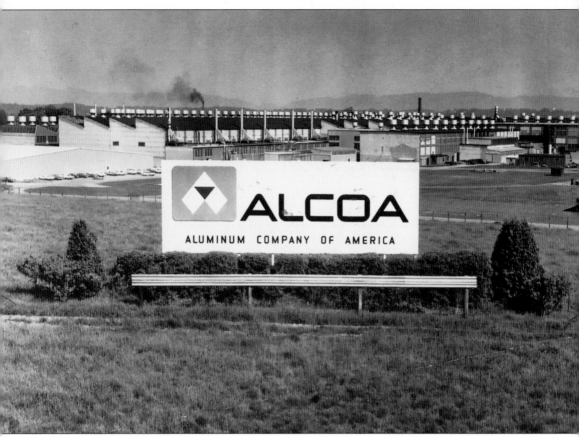

For many years, this sign stood on the Aluminum Company of America's West Plant property in a field adjacent to Alcoa Highway. The West Plant, a fabrication plant, was closed in 1989, and today, the property is vacant. On the last day of production at this plant, every department set a new production record. (Courtesy of Becky Blankenship Darrell.)

On the Cover: The first Alcoa City Commission is pictured in 1919 at a meeting inside building 68 at the Aluminum Company of America's South Plant. From left to right are V.J. Hultquist, city manager; S.A. Copp, commissioner; Mayor C.L. Babcock; W.V. Arnold, commissioner; Homer A. Goddard, city attorney; and A.B. Smith, city recorder and treasurer. Largely hidden to the left of the picture is Blair Wilcox, city engineer. (Courtesy of City of Alcoa.)

IMAGES
of America

ALCOA

David R. Duggan and George Williams
Foreword by Lamar Alexander,
US Senator from Tennessee

ARCADIA
PUBLISHING

Published by Arcadia Publishing
Charleston, South Carolina

Printed in the United States of America

Library of Congress Control Number: 2011923672

For all general information, please contact Arcadia Publishing:
Telephone 843-853-2070
Fax 843-853-0044
E-mail sales@arcadiapublishing.com
For customer service and orders:
Toll-Free 1-888-313-2665

Visit us on the Internet at www.arcadiapublishing.com

*To the memory of my mother, Earlene Duggan, and
our friends, Charles and Joann Danner*

*To the memory of my brother, Richard Williams; my sister, Jeanette
Williams Roper; and my parents, Richard and Gertrude Williams*

CONTENTS

Foreword 6

Acknowledgments 7

Introduction 8

1. First in Aluminum 11

2. Education 29

3. Sports 53

4. Homes, Buildings, and Places 75

5. Commerce 89

6. Activities, Individuals, and Families 101

7. Faith 119

FOREWORD

Maryville mayor Samuel Everett must have been quite a salesman in 1914. Aluminum Company of America (ALCOA) executives from Pittsburgh, Pennsylvania, had looked at several sites in East Tennessee before they bought 700 acres in North Maryville for a large smelting plant. Two decades before the birth of the Tennessee Valley Authority, ALCOA coveted cheap electricity for its smelter from dams on the Little Tennessee River as it hurtled down gorges in the Great Smoky Mountains.

For his trouble, Mayor Everett was tarred and feathered by irate citizens who "rode him out of town on a rail"—or at least, this was the story I was told growing up in Maryville. A century ago, even though their incomes were less than one-third the national average, Blount Countians did not appreciate northern outsiders arriving with giant plants intent on changing life in the foothills of the Smokies. But ALCOA's plants and the world wars' insatiable demand for aluminum did just that. Steelworker wages negotiated in Pittsburgh created good jobs for 12,000 East Tennessee workers, including my father.

In 1940, shortly before I was born, ALCOA hired my dad, Andrew Alexander, to be safety director at the smelting plant. They paid him twice what he was making as principal of West Side Elementary School. (Dad maintained his interest in education by serving for 25 years on the Maryville school board.) Each day, he would carpool back and forth to the plant, often bringing home movies of aluminum pioneers Charles Martin Hall and Arthur Vining Davis. After a while, my sisters and I could recite from memory the origins of the Aluminum Company of America. Most of our classmates and friends were ALCOAns. Many Blount County families we knew included someone who worked at the plant and farmed at home.

These jobs produced strong families, good schools, and stable communities. Even while racial segregation persisted, this was also true for African American families, many of whom had come to help build the plants and then stayed to work at them. For example, Allan Houston's great-grandmother and Lynn Swann's grandmother were close friends of my mother. Growing up, I saw them often. Both of my first Scoutmasters, my college scholarship, and one of my first jobs all came from ALCOA. Many of the interesting people I met from other places had worked at ALCOA installations around our country and the world.

During this last century, Alcoa has become much more than a company town. But the legacy of the aluminum makers from Pittsburgh is one we should honor. Those northerners and Mayor Everett, who was run out of town for inviting them to North Maryville, have made our lives richer.

—Lamar Alexander
US Senator from Tennessee

ACKNOWLEDGMENTS

The authors are grateful to those who have shared their photographs of life in Alcoa. An additional measure of gratitude is due to the City of Alcoa, Alcoa City Schools, the Alcoa High School Alumni Association, Alcoa, Inc., and the *Daily Times*, as well as to Don Bledsoe, Patsy Cook Bridges, Shirley Carr-Clowney, Dick Guldi, Geneva Harrison, Nelda French Kidd, Freda McCulloch, Vernon and Margaret Ann Osborne, and Kathy Overholser, granddaughter of V.J. Hultquist, for the wonderful pictures they have made available. No acknowledgment can measure our indebtedness to Kari L. Duggan—wife of the coauthor and daughter of retired Alcoa, Inc., engineer Willis D. Ludwig Jr. and Betty Ludwig—for her many hours spent scanning photographs for us and to Linda Albert of the *Daily Times*, who came to our rescue with her offer of superb technical assistance, an enthusiastic and supportive spirit, and her encouraging smile.

INTRODUCTION

In his poem *Nothing Gold Can Stay*, Robert Frost reminded us that days and years must pass, and with them the life we know and, indeed, our very lives. But something gold can stay preserved in our collective memory and in our shared experiences, indelibly recorded in our heritage and history—and in the photographs that capture moments in time along the way. It is our desire, in this book, to tell the story in pictures of Alcoa and, thus, to preserve one piece of our heritage.

Alcoa was incorporated in 1919 by Aluminum Company of America (ALCOA or Alcoa, Inc.) officials working in consort with Babcock Lumber Company leaders and state senator Dr. J. Walter McMahan, an ALCOA employee. ALCOA desired to create a residential community for its workers as it proceeded to establish what would become, at one time, the aluminum production center of the world.

Does it detract from the life of the community that was created here to note that ALCOA's chief purpose was to produce aluminum and sell it at a profit? Such is the purpose—and the primary obligation to its shareholders—of any company.

Certainly Alcoa was, in many respects, the quintessential company town. The company built and owned the homes, streets, utilities, and recreational facilities. Company employees managed the city and controlled its government, and the company even employed the schoolteachers.

In other respects, however, the city was not a typical company town. The company evidenced its desire to provide a high quality of life for its workers by paying wages that set new standards for locally prevailing wage rates; establishing excellent water, sewer, and electric utilities at a time when most Blount Countians were without such services; bringing to the city superb educators; and setting aside one acre of park for each 100 residents.

All of this was done pursuant to sound municipal planning, with Alcoa being among the first planned communities in Tennessee. The company also brought innovative municipal government to the area; Alcoa was one of the first cities in the nation to employ a city manager/commission charter—even if the first city manager outside the company was not hired until 1956.

In time, the city achieved its independence. From the beginning of developing the town site, workers were encouraged to buy their homes, and the company financed the purchases. By the 1950s, city government had become independent of the company, and utilities were transferred to the city by 1960.

There is another aspect of life in Alcoa that may not be glossed over. Life was segregated here, as it was in most of the nation, including by deed restrictions that prevented the conveyance of homes in the white communities to African Americans. African American and Mexican laborers were heavily recruited by the company because it was believed that their darker skin color would help them withstand the heat of the pot rooms and, perhaps, because of the lower wages they would command.

Even within the confinements of segregation, however, there were some differences in Alcoa. Company officials believed that African American workers also deserved quality community

life, even if in the separate Hall and Oldfield communities. Arthur Vining Davis, the company's powerful board chairman, wanted the best African American school system in the South for the company's laborers. Recreational and other facilities were also provided, as evidenced by construction of the Community Building and the Commercial Building in the Hall community in 1919. While priority was usually given to the white communities, facilities and services were extended to the Hall and Oldfield communities as well. The available housing, even if the homes were smaller, was quite an improvement over the southern agricultural environment African Americans left behind to come to Alcoa. Although not constructed until 1926 and after schools for white students were built—Springbrook in 1921 and Bassel in 1923—Charles M. Hall School would be, along with churches, the center of community activity and the envy of other African American communities across the region.

Like any community, what is most significant about Alcoa is its people—the lives they led, the families they raised here, the life they created, and the legacies they established. It is our intent to present a picture of that life through about 1970. In doing so, we have striven to use photographs that, for the most part, have not previously been published in book form.

We hope you enjoy this book and that it informs you about a people and way of life that are gone but yet remain in each person who calls Alcoa home.

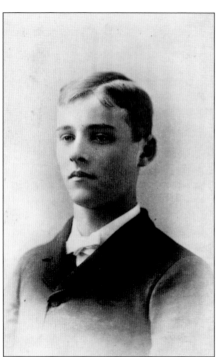

Prior to 1886, aluminum was considered a precious metal, and its production was very expensive. In that year, Charles Martin Hall, shown at left, discovered a new, commercially affordable electrolytic process of producing aluminum from bauxite and, thus, made possible the birth of the modern aluminum industry. (Courtesy of Alcoa, Inc.)

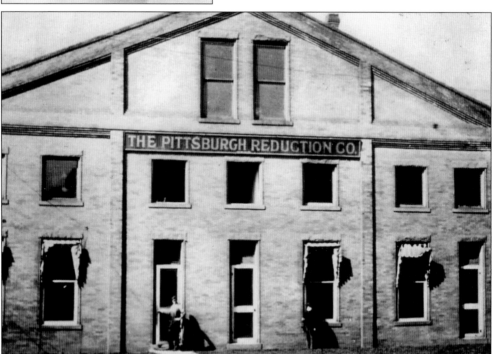

The Pittsburgh Reduction Company was founded by Alfred E. Hunt, George H. Clapp, Charles M. Hall, Romaine C. Cole, and Arthur Vining Davis. The company was formed after Hall invented the process that rendered the commercial production of aluminum economically feasible. The company was the forerunner to what would become, in 1907, the Aluminum Company of America. (Courtesy of Alcoa, Inc.)

One

FIRST IN ALUMINUM

The Aluminum Company of America came to East Tennessee to produce aluminum. Beginning in 1914 with the opening of a reduction plant, the company would eventually construct three facilities in Alcoa that came to be known as the South Plant (smelting), West Plant (fabrication), and North Plant (fabrication).

The company acquired 3,300 acres in 1913, and construction of the first South Plant units and a town site was soon underway. Before World War II, Alcoa was home to the aluminum production center of the world.

The North Plant, completed in 1942 and the last to be constructed, was believed to be the largest factory under one roof in the world. It featured a half-mile-long continuous rolling mill that rolled sheet aluminum used, among other things, to build bombers during World War II. During the war, employment reached a peak of 11,000 to 12,000 workers.

Alcoa featured a diverse population that, in 1920, included 1,708 whites, 1,482 African Americans, and approximately 150 Mexicans. For these workers, Edwin S. Fickes, the company's chief engineer and, later, a senior vice president, and Robert F. Ewald, a hydraulic engineer, laid out a formal plan for the city that included homes, streets, schools, churches, parks, recreational facilities, and water and sewer utilities for a proposed town of 10,000 persons. A progressive town for its time, Alcoa featured the highest percentage of homes with indoor toilet facilities in the state.

John D. Harper, a Blount County native, rose to the position of company president and, later, chairman of the board, using his own success to bolster the Tennessee operations. As late as 1970, ALCOA's Tennessee operations remained the apple of the company's corporate eye, and Harper attended the city's 50th anniversary celebration in 1969.

Arthur Vining Davis, left, became president and, later, chairman of the board of ALCOA. He was the company's largest stockholder and amassed a great fortune. At the time of his retirement in 1958, he was one of the richest men in the world. The man on the right is unidentified. (Courtesy of Alcoa, Inc.)

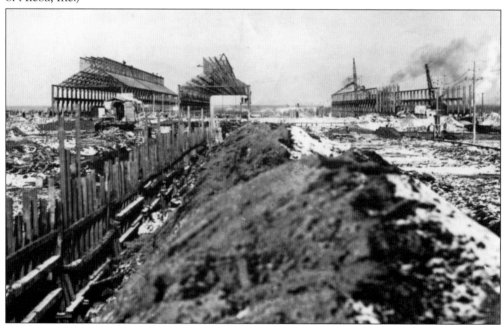

Construction of the reduction plant is pictured around 1913. The plant was in operation by 1914. The reduction plant and carbon plant, which was in operation by 1917, comprised what became known as the South Plant. The reduction plant contained the pot lines used to smelt metallic aluminum. (Courtesy of Alcoa, Inc.)

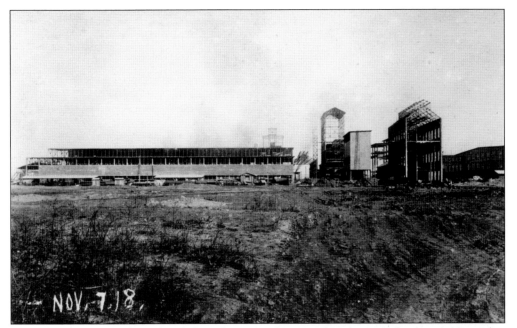

Construction of the carbon plant baking furnace is shown in this photograph taken on November 7, 1918. The first carbon plant was in operation by 1917, producing carbon linings to be used in the smelting pots. (Courtesy of Alcoa, Inc.)

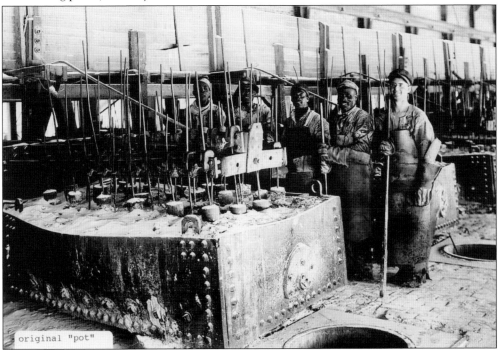

In this c. 1920 photograph, company laborers stand alongside one of the original Hall-type smelting pots in the pot rooms of the reduction plant. By 1919, the company had constructed seven pot lines. The company heavily recruited African American workers because it was believed that their skin color would help them withstand the heat of the pot rooms. (Courtesy of Alcoa, Inc.)

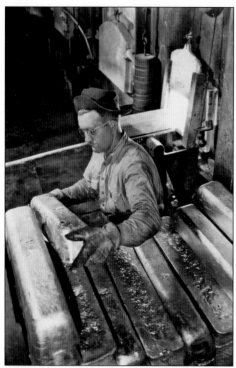

A worker is shown lifting an aluminum ingot in the 1920s. The ingots were placed into remelt furnaces that produced aluminum plate or sheet from which products could be made. The early 100-pound-capacity furnaces would have a 20,000-pound capacity by 1931. (Courtesy of Alcoa, Inc.)

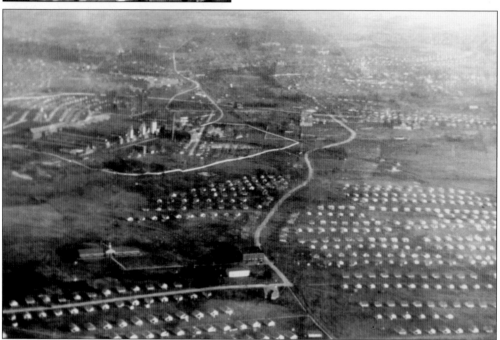

The Hall community, with its company homes originally built for African American workers, is shown in this c. 1930 photograph. The South Plant is seen in the center background, and Charles M. Hall School is visible in the left foreground. The Commercial Building, the white frame Community Building, and St. Paul A.M.E. Church are shown in the center foreground. (Courtesy of City of Alcoa.)

This c. 1919 photograph shows the Mule Barn (on the left) when the Aluminum Company of America school, later named Bassel School, was located there. Construction of the first 180 company homes began in 1916. Homes along Lincoln Road are shown in the center, along Glascock and Lindsay Streets to the left and Telford Street to the right. Initially, the Bassel community was called Basseltown. (Courtesy of Alcoa, Inc.)

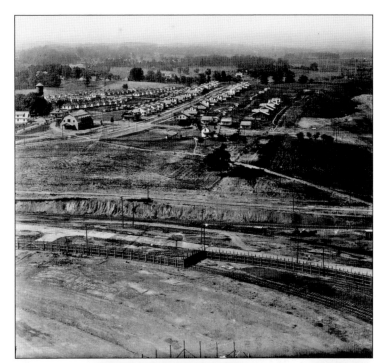

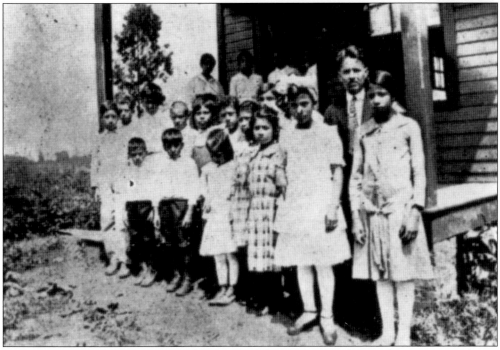

Prof. Alexander B. Oropeza is pictured in 1919 with his Mexican students. Alcoa's 1920 population included 150 Mexicans. In 1920, the centennial of Mexican independence was celebrated. Homes were decorated with green, white, and red national colors and with American and Mexican flags. Portraits of Mexican national heroes were hung in the Community Building in the Hall community. Racial conflicts in the 1920s drove Mexicans from the community. (Courtesy of Alcoa, Inc.)

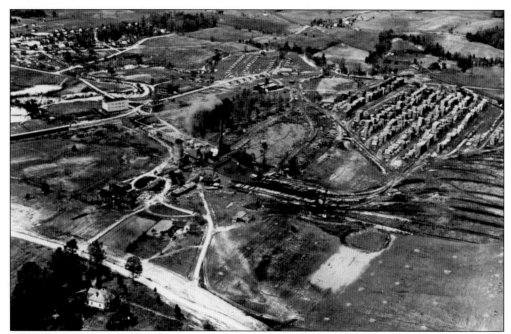

Babcock Lumber Company is shown here around 1920. The company acquired 350 acres along Pistol Creek in 1916 for saw and finishing mills. Shown at the top of the photograph are some of the 200 company homes built in 1916 and 1917. Also pictured in the upper left corner, near the creek and along Wright Road, are the company commissary, office building, and three-story clubhouse. (Courtesy of City of Alcoa.)

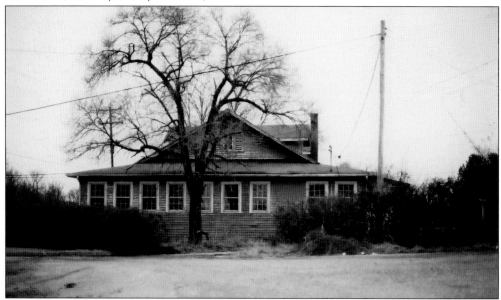

The Babcock Lumber Company office building is shown in this photograph. The company was sold to Bond, Woolf, and Company in 1934 and to Veach-May-Wilson in 1946. The company, at one time, was the nation's leading producer of hardwood lumber. It was located in the Vose community, and the streets there were named for the company's raw materials, including Poplar, Birch, Oak, Maple, Locust, and Cedar Streets. (Courtesy of Freda McCulloch.)

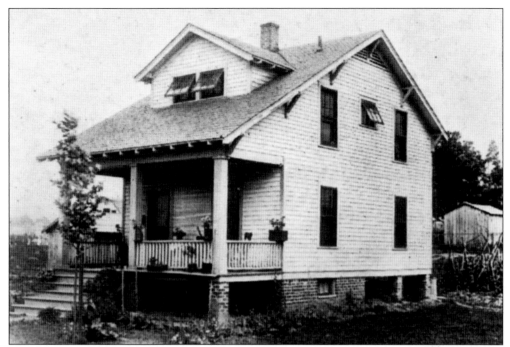

This company home at 101 Lincoln Avenue (before the street became known as Lincoln Road) was advertised for sale in August 1920 for $2,558. ALCOA offered to finance the purchase at $34.11 per month for 10 years. The home was billed as featuring six rooms, a slate roof, and "plenty of closets, a bath, sewer connection, and hot and cold water." The advertisement also noted finished sidewalks and partially installed street pavement. (Courtesy of Alcoa, Inc.)

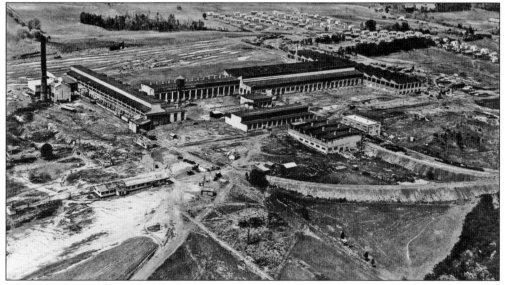

ALCOA's sheet mill (West Plant) was begun in 1919, and the first aluminum sheet was rolled in 1920. The homes that are shown were built as part of the company's intensive town site construction program. From 1917 to 1920, approximately 700 homes were built, along with water and sewer lines. Between 1918 and 1924, three thousand shade trees were planted along streets and in the parks. (Courtesy of City of Alcoa.)

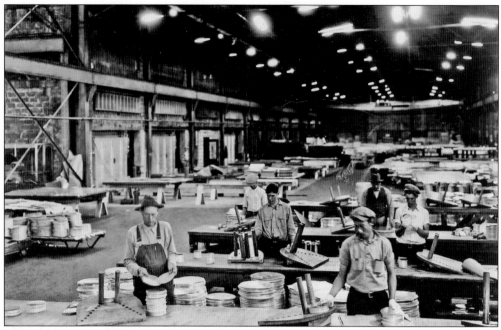

These 1920s-era workers are inspecting aluminum discs at the West Plant. The discs were used to produce cookware, primarily pots and pans, among other things. As a certain number of discs were inspected and approved, pieces of paper were placed between them to keep track of the count. (Courtesy of Alcoa, Inc.)

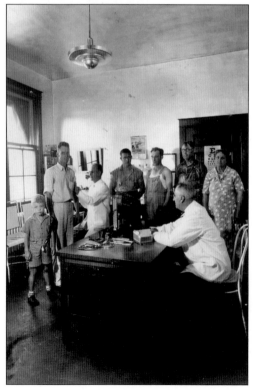

ALCOA provided health care to its workers and their families, including a field hospital in the area where East Tennessee Medical Group is presently located. In this 1920s photograph, workers and family members are being examined by company doctors at the West Plant office building. Dr. Lowe is seated at the desk. (Courtesy of Alcoa, Inc.)

As manager of the construction division and property manager for the company, V.J. Hultquist oversaw the construction of the city and then served as its city manager from 1919 to 1948, believed to be the longest tenure of any city manager in the nation. He is pictured here around 1930. A plaque in Springbrook Park honors him as the father of the park. (Courtesy of Kathy Overholser.)

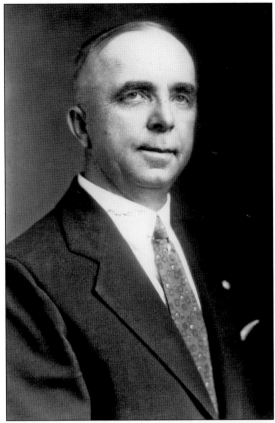

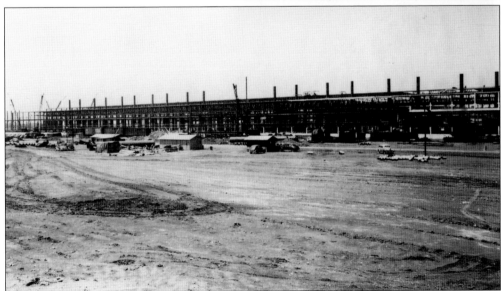

ALCOA's North Plant, a fabrication facility shown here under construction, was opened on June 5, 1941. This plant's production greatly aided the nation's war effort during World War II. When opened, this plant was the largest factory under one roof in the world, and company employment reached a peak of 11,000 to 12,000 workers. (Courtesy of Alcoa, Inc.)

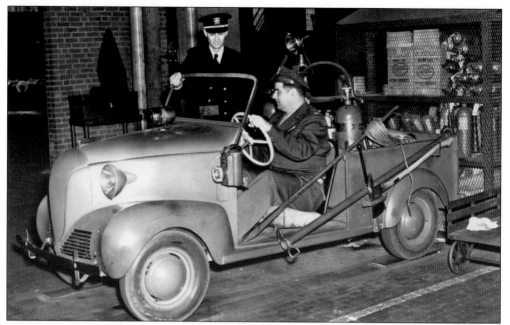

This picture was taken inside the North Plant in the 1940s. At 55 acres, the plant was so large that workers used electric carts and Crosley cars to get around inside the building. This Crosley vehicle was specially ordered and converted for use as a fire truck in order to provide access to small places. (Courtesy of Alcoa, Inc.)

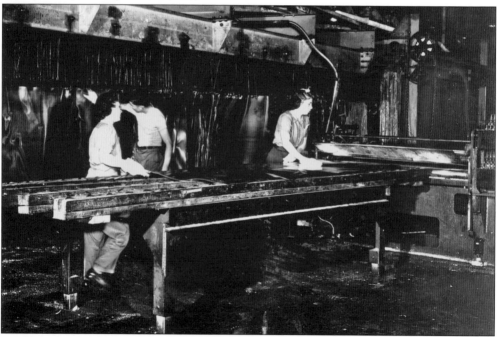

Just like other factories across America during World War II, female workers were heavily relied on as company laborers. In this 1940s photograph, workers at the North Plant are engaged in quality inspection of an aluminum sheet. Specifically, these workers were checking the gauge of the sheet. (Courtesy of Alcoa, Inc.)

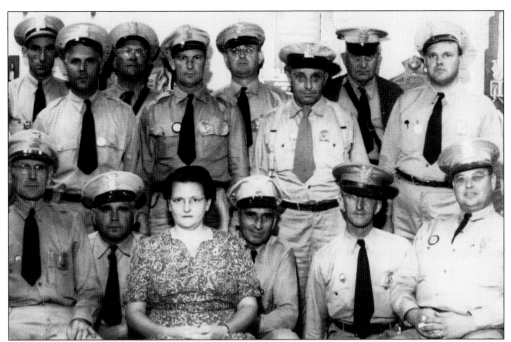

ALCOA employed numerous plant guards during World War II. A woman was included in each group of guards in order to allow for inspection of women's restrooms. The woman shown in this picture is Pearl Headrick. The men are unidentified. (Courtesy of Freda McCulloch.)

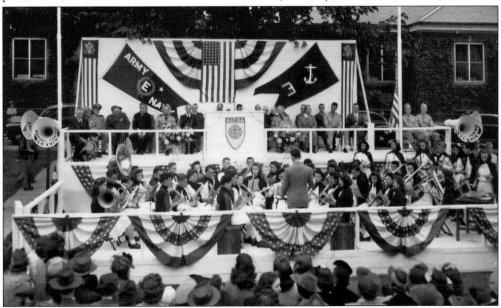

The Navy E Award was presented to ALCOA on May 14, 1942, for effort and efficiency in production achievement. Rear Adm. Bryson Bruce presented the award. Gov. Prentice Cooper and company president Roy A. Hunt attended the ceremony, and the Alcoa High School band played for the event, which was broadcast by WROL, WNOX, and WBIR radio stations. The presentation took place in front of the West Plant office building. (Courtesy of Alcoa High School Alumni Association.)

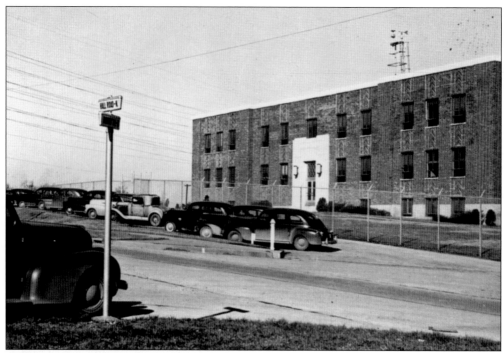

Constructed in 1942, ALCOA's South Plant office building on Hall Road is pictured above in the 1940s and below in the 1960s. This elegant building symbolized ALCOA's contribution to this area, its industrial excellence, and its world market strength. When this building was demolished in 2008, the marble around the front door was used to make marble tops for tables in the Rigid Packaging Division office building at the North Plant. (Both courtesy of City of Alcoa.)

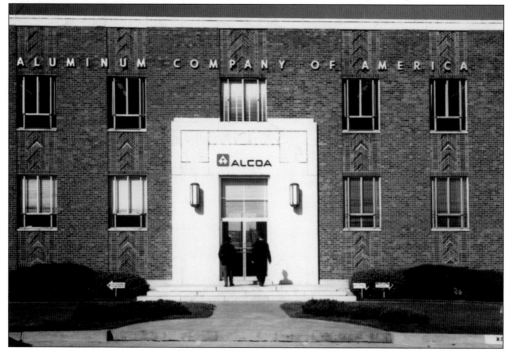

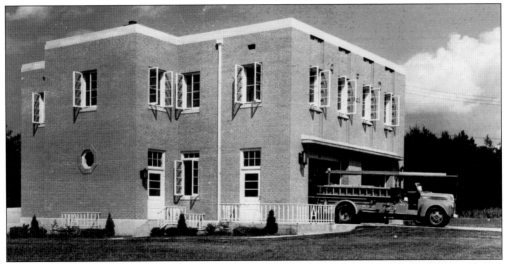

The city's fire department was organized separately from the company in 1942 and moved into this Springbrook Road station in 1943. Pictured in front of the old fire hall is the first fire engine the city purchased from ALCOA, an open-cab 1940 Ford equipped with a Buffalo fire pump. (Courtesy of Alcoa Fire Department.)

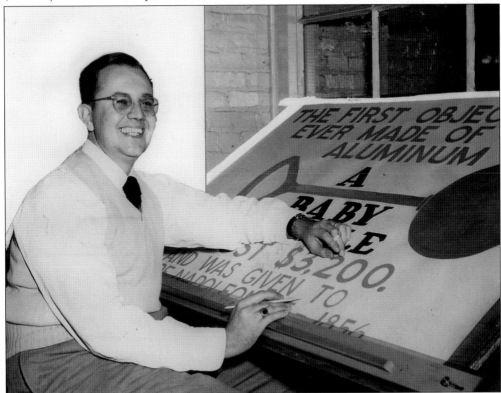

Company employee Stone Norton is shown here, around 1948, drafting a depiction of the first aluminum object, a baby rattle presented to the Prince Imperial, son of Emperor Napoleon III, in 1856. Evidencing the precious nature of aluminum then, the rattle cost $3,200 to produce. (Courtesy of Becky Blankenship Darrell.)

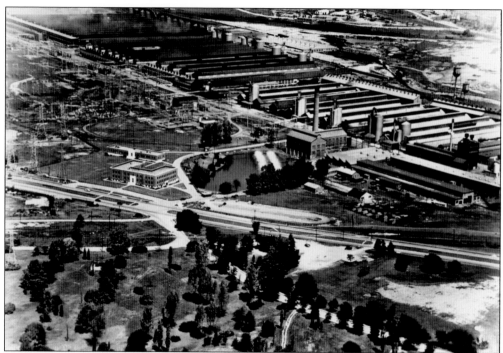

This aerial photograph shows the South Plant, where smelting operations were headquartered. At one time, Alcoa was the world's largest aluminum production center. In the middle left of the picture is the company's office building on Hall Road. When this picture was taken in the 1950s, Rankin Road at the bottom was still a through street to Hall Road. (Courtesy of Alcoa, Inc.)

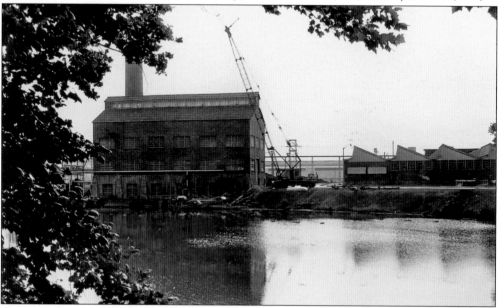

Pictured around the 1930s are the company's steam plant and cooling pond at the South Plant. The location of the steam plant and pond in relation to the remaining portion of the South Plant can be seen in the preceding photograph. The steam plant has since been demolished. (Courtesy of Alcoa, Inc.)

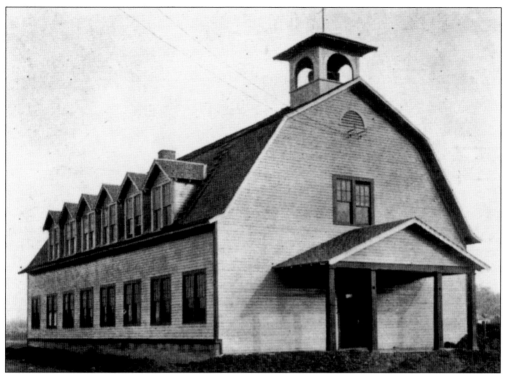

Pictured is the Mule Barn in 1919. ALCOA purchased the property in 1913 from Mary Rorex and erected a barn to house mules used in construction excavation. In 1918, the barn was quickly remodeled to house the first Bassel School and offices, and this picture was taken just after the building was readied for school use. The city municipal building was located here from 1924 until 1961. (Courtesy of Alcoa, Inc.)

The City of Alcoa has established a reputation for high-quality municipal services, including curbside brush and bulk waste collection and recycling. Shown here is a contracted crew, trimming trees and collecting brush along Faraday Street in front of Alcoa High School around 1950. (Courtesy of City of Alcoa.)

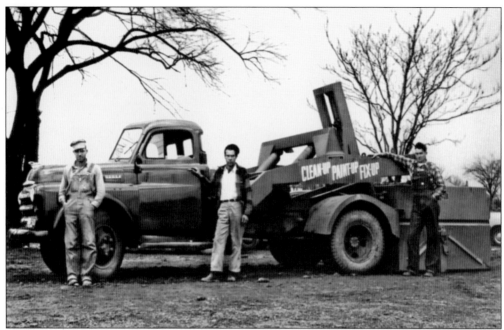

The city's emphasis upon quality services and community life is evidenced in this 1951 photograph, which features a sanitation crew and trash collection truck promoting the city's Clean-up, Paint-up, Fix-up campaign. Shown from left to right are sanitation workers June Ogle, Jake Debuty, and Cam Tucker. (Courtesy of Don Bledsoe.)

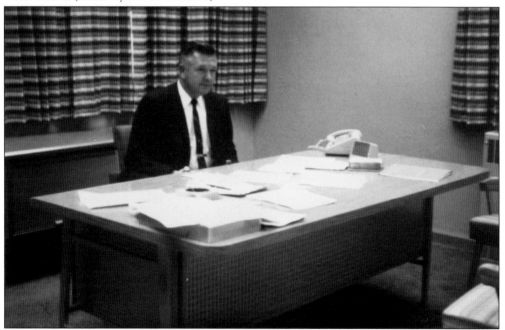

Ross Walker, shown seated at his aluminum desk, served as city manager from 1956 to 1968. He was the first Alcoa city manager who was not an employee of ALCOA. Walker's hiring further evidenced the independence the city gained from the company during this time period. Walker oversaw the transfer of all utilities to the city. (Courtesy of James Clodfelter.)

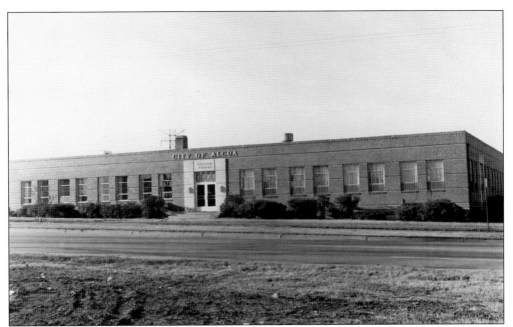

This Hall Road building served as the Alcoa Municipal Building from 1961 to 2000. The building housed ALCOA's general services and electrical offices prior to its use by the city. The move from the Mule Barn to this building came at the time when the city had achieved its independence from the company, the water utility system having been transferred to the city in 1960. (Courtesy of City of Alcoa.)

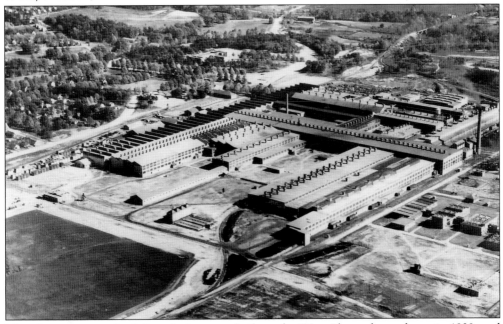

The aluminum powder (albron) plant was built at the West Plant, shown here, in 1929, and a second unit was constructed at the plant in 1930 and 1931. At one time, the nation's entire supply of ALCOA Wrap aluminum foil, first produced in 1945, was made here. (Courtesy of City of Alcoa.)

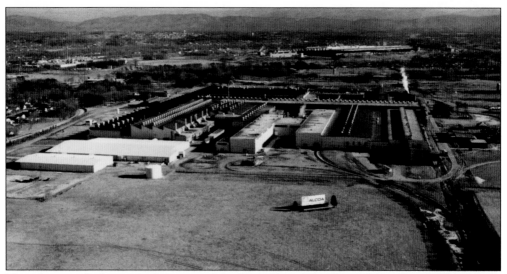

This photograph shows another view of the West Plant. The West Plant office building, Mills Street, and old company homes located on Lodge Street can be seen to the left of the plant. The gatehouse was located behind the plant beyond the terminus of Faraday Street. After the 10:00 p.m. shift change on Friday nights, workers often would gather there to play bluegrass music. (Courtesy of Becky Blankenship Darrell.)

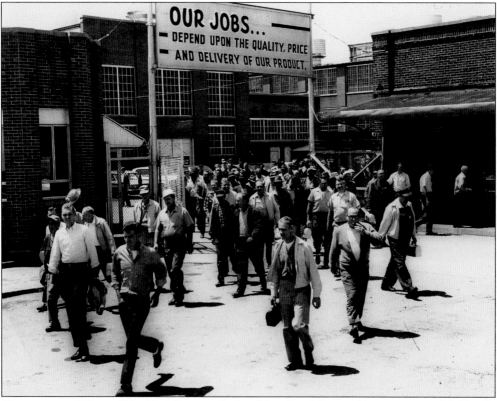

Generations of Blount Countians have worked at "the plant." Pictured here is a typical 2:00 p.m. shift change at the West Plant around the 1960s. (Courtesy of Alcoa, Inc., and City of Alcoa.)

Two

EDUCATION

Alcoa residents have long been proud of their city schools. The company understood the importance of education and strove to hire the best teachers it could. Before ALCOA established schools for its workers' children, however, Babcock Lumber Company provided a school for its laborers' children. In 1916, Babcock renovated and renamed the Green School, which had been part of the Blount County system. The new school, Vose, and the community where it was located were given the maiden name of the mother of C.L. Babcock, president of the lumber company and Alcoa's first mayor.

Rapid growth in the school population in what was then known as North Maryville forced ALCOA officials to quickly convert a mule barn for school use in 1918. The Aluminum Company of America School, later named Bassel, was located there until the new Bassel building was opened in 1923. Springbrook School, home to grades 1 through 12, opened in 1921. A new Alcoa High School building was opened in 1939, and the present high school building was added to that structure in 1964.

A separate school for African American children was located upstairs in the Commercial Building in the Hall community in 1919. The school was initially known as the Peniel School, then, in 1920, it became Walnut Hill School. Prior to 1919, there were two schools (both having just one room) on Americus Avenue, and later, four cottages on Edison Street were used as schools. A new school, Charles M. Hall, was opened in 1926, although it did not provide an education beyond the 10th grade until the 1938–1939 school year.

There was a separate school for Mexican children located in a home, and Alexander B. Oropeza was the teacher.

Alcoa's schools attained a reputation for being among the finest public schools in the South. The Alcoa city schools continue to be considered among the best schools in the state.

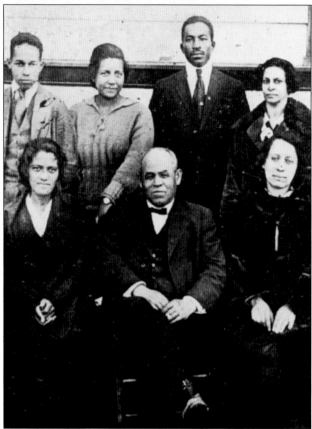

Shown here in 1918 is one of two small houses used as an African American school. It was located on Americus Avenue, which no longer exists, west of Hall Road. This building housed grades two and above, and Professor Moss was the principal. Four new cottages on Edison Street were home to the school from the fall of 1918 until it moved to the Commercial Building in March 1919. (Courtesy of Alcoa, Inc.)

Early African American school faculty members are pictured here in 1919. From left to right are (first row) Clara Turner, Principal John T. Arter, and Celia Griffin; (second row) Ralph M. Arter, Mable Cloud, E.Z. Jackson, and Dollie Warren. John T. Arter was known for strong community leadership, and he strove for better pay, schools, and transportation for African American residents. (Courtesy of Alcoa, Inc.)

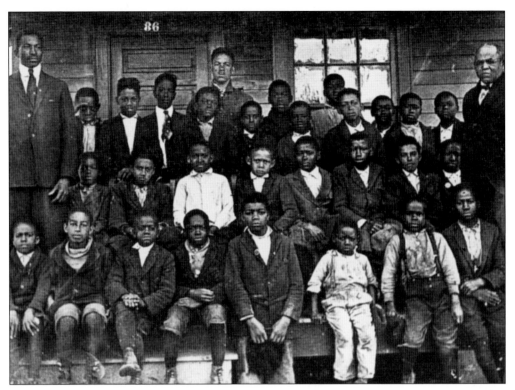

Pictured above are African American manual-training students in 1919. E.Z. Jackson, the teacher, stands at the far left of the back row, and Principal John T. Arter stands to the far right of that row. Below, students and faculty are shown, also in 1919, outside the Community Building. At this time, the school had 318 students, including 87 night students. (Both courtesy of Alcoa, Inc.)

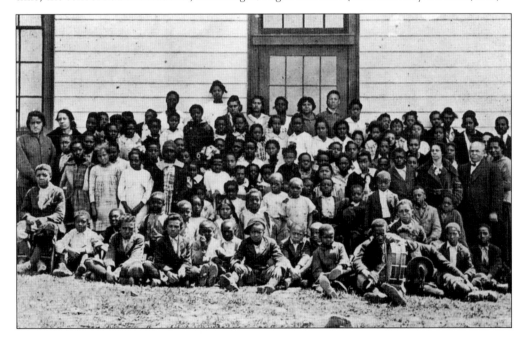

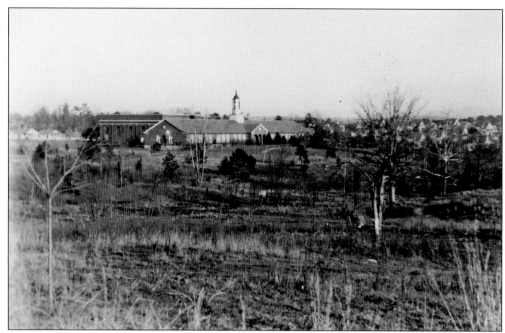

Springbrook School is shown above in the 1930s and below in the 1940s. The school was constructed by the city at a cost of $68,079 and opened in 1921. Alcoa High School was located here until 1939. High school classes were in the left portion of the building and elementary classes in the right. The gymnasium behind the building was opened in 1928. The high school's first graduating class, in 1925, was comprised of two students, Marguerite Settles Beightol and Rossie Cochran. The homes shown to the left and right of the picture above were constructed by ALCOA for its workers. The hedgerows shown in the picture below lined the sidewalks extending toward Darwin Street. (Both courtesy of City of Alcoa.)

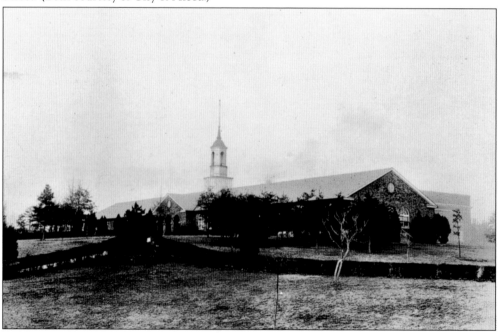

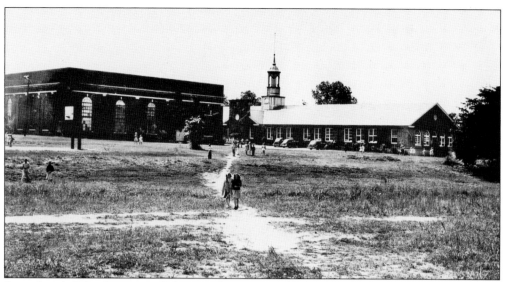

Springbrook School is pictured above in the 1940s and below in 1951. The school, as well as the Springbrook community and its park, are named for the brook that flows through the park and former school grounds. The picture above was taken from Alcoa Road. In the 1940s, "Teen Town" activities were conducted in the gymnasium, including dances, games, cakewalks, and music. The school was destroyed by fire in 1968 just before the new school year began, but the gymnasium was saved and continues to be used as part of the Blount County Parks and Recreation Commission system. After the fire, elementary classes had to be quickly relocated to the gymnasium and the 1939 Alcoa High School building. (Above, courtesy of Alcoa, Inc.; below, courtesy of Alcoa High School Alumni Association.)

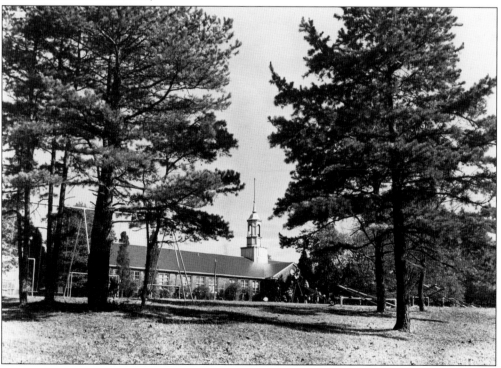

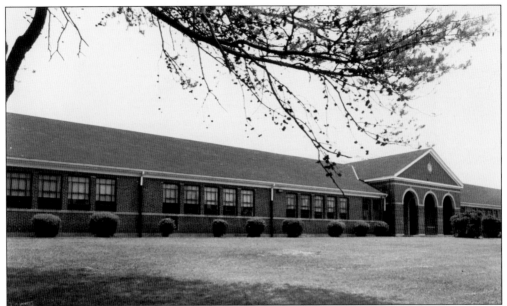

Charles M. Hall School was constructed by the city at a cost of $64,028.95 and was opened in 1926 for the education of African American youth. The school provided education only through the 10th grade until the late 1930s. The first senior class was in 1939. Prior to that time, students who wished to complete the 12th grade had to transfer to Austin High School in Knoxville. Prior to construction of a gymnasium in 1951, Hall High basketball teams played their games in the Community Building. (Courtesy of City of Alcoa.)

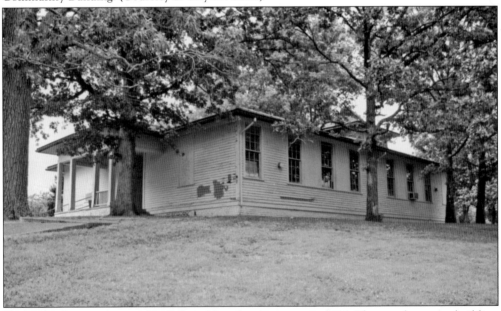

Vose School was constructed by Babcock Lumber Company in 1916. The new four-room building was constructed on the site of the former Green School. The school and the Vose community were named for C.L. Babcock's mother. Vose was closed and used as a gymnasium for Alcoa High School basketball games until the Springbrook gymnasium was opened in 1928. Later reopened and used as a city school, it was closed in 1964. (Courtesy of David R Duggan.)

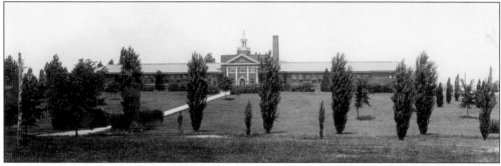

Bassel School was constructed by the city at a cost of $61,108.73 and opened in 1923. The school and community were named for Guy M. Bassel, city engineer from 1920 to 1929. The school, located on Joule Street, was home to grades one through eight for the Bassel community. East Tennessee Medical Group's office building is now located on the site. (Courtesy of City of Alcoa.)

Pictured around 1925 are, from left to right, Thomas Phillips Sheffey, Ida Gertrude Sheffey, Margaret Sheffey, Billy Carrol Sheffey (child), Josephine Sheffey Irwin, and D. Lewis Irwin. Josephine Sheffey Irwin, a former Maryville Polytechnic School teacher, was Alcoa's first female principal, serving at Bassel from 1918 to 1921 and Springbrook from 1921 to 1926. She died in 1927. (Courtesy of Lynn Sheffey.)

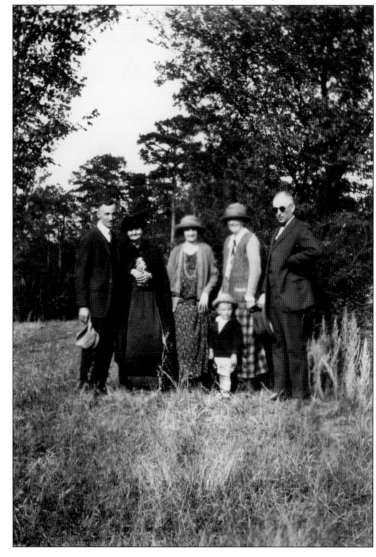

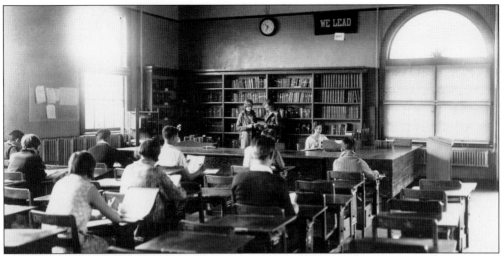

Students are shown in the Alcoa High School library at Springbrook School in the 1920s. The library was located on the end of the building closest to Alcoa Road. Some time after 1954, when the new high school gymnasium was built and the Springbrook gymnasium was reconfigured to include a new cafeteria and upstairs classrooms, the library was relocated upstairs in the gymnasium. (Courtesy of Alcoa High School Alumni Association.)

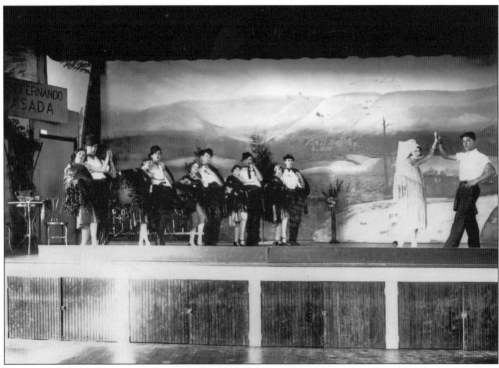

Alcoa High School students are shown performing the Spanish operetta *El Bandido* on the stage of Springbrook gymnasium in 1929. The hand-painted backdrop stage curtain presents a view of Cades Cove, a part of the Great Smoky Mountains National Park in Blount County. (Courtesy of Alcoa High School Alumni Association.)

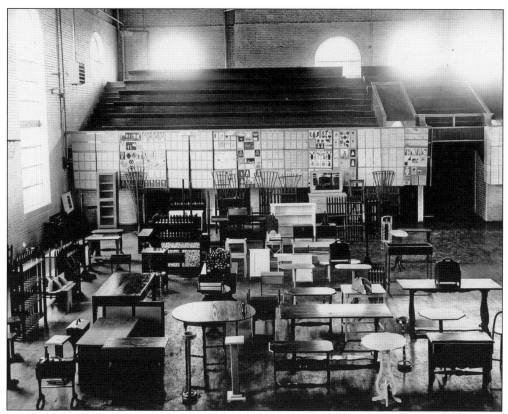

Student industrial arts products are shown inside Springbrook gymnasium in 1929. The basketball court ran perpendicular to the present court, and bleachers were attached to the wall closest to the school. A kitchen and lunchroom were located beneath the bleachers in the late 1940s. The lunchroom was later relocated to the left of the gymnasium, with classrooms and a new library located above the new cafeteria. (Courtesy of Alcoa, Inc.)

Springbrook School second-grade students are shown with their *Happy Times* readers in March 1939, participating in a reading group lesson on safety. The poster on the blackboard told them, among other instructions, to "Look both ways when crossing a street, never walk on a railroad track, and refuse rides from strangers." (Courtesy of Alcoa High School Alumni Association.)

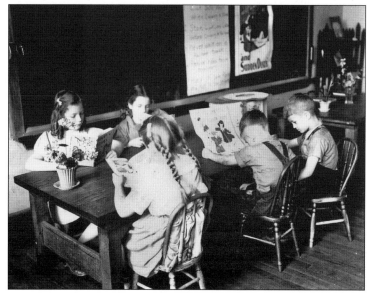

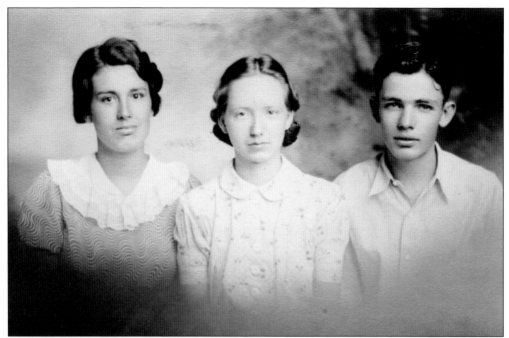

Shown from left to right are Alcoa High School students Leona Myers, Irene Maples, and H.L. Hendricks. They were the first-, second-, and third-prize winners, respectively, in the 1936 Blount County high school essay competition, "A Half Century of Aluminum," marking the 50th anniversary of Charles M. Hall's aluminum production process discovery. University of Tennessee and Maryville College professors judged the competition. (Courtesy of Alcoa High School Alumni Association.)

Springbrook School students are shown displaying their Palmer Method penmanship certificates in May 1934. The students are pictured outside the basement level of the Springbrook gymnasium on the athletic field that is still used for recreation league softball games. Industrial arts classrooms and athletic locker rooms were located in the basement. (Courtesy of Alcoa High School Alumni Association.)

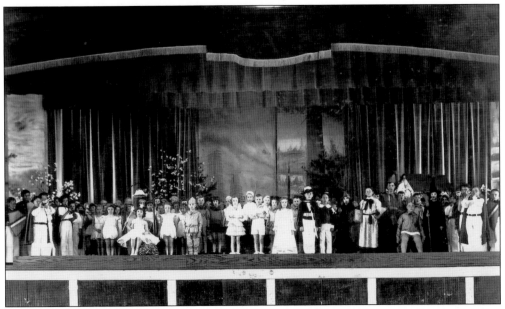

Second- and third-grade Springbrook School students are shown in the gymnasium performing a school play in 1936. From their inception, the Alcoa city schools emphasized instruction in the arts, including drama and music. School assemblies and various performances were conducted in the gymnasium. (Courtesy of Alcoa High School Alumni Association.)

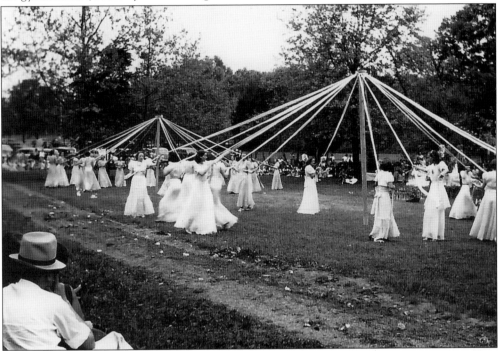

Pictured here are May Day activities conducted on the Springbrook School grounds in May 1939. Springbrook Park grounds also provided the students' playground. The youth are shown in the area of the park closest to Darwin Street and the back of Alcoa First United Methodist Church, adjacent to Springbrook Creek. (Courtesy of Alcoa High School Alumni Association.)

Above, students and community residents are shown on the Springbrook School grounds while observing the May Day activities in 1939. In the upper left corner of the picture, the old wooden home, long since demolished, can be seen. It stood on a rise above Darwin Street, then known as Langley Street. Below, the wooden structure is shown. According to a 1934 ALCOA press tour guide, the structure was said to be the second oldest house in Blount County. The guide stated that a number of attacks were made by Native Americans against the occupants. (Above, courtesy of Alcoa High School Alumni Association; below, courtesy of City of Alcoa.)

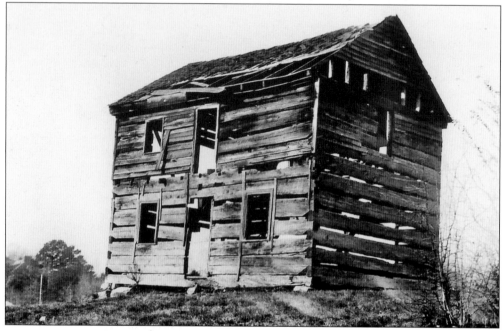

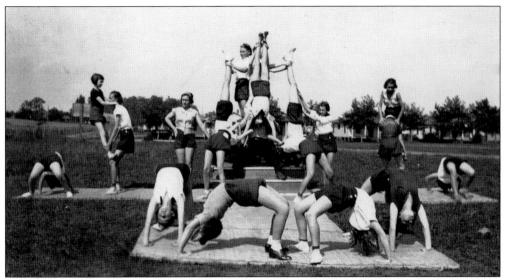

Springbrook School students are shown performing gymnastics exercises in 1939. In the background are company homes located on Dalton Street. (Courtesy of Alcoa High School Alumni Association.)

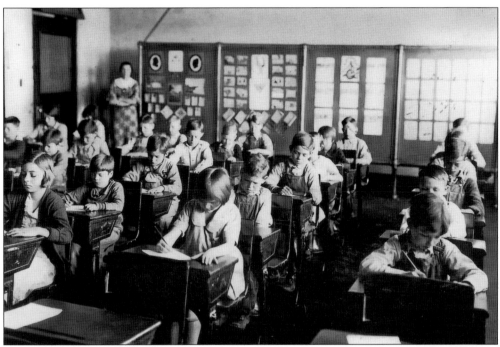

This picture shows a typical Springbrook School elementary classroom in 1933. Each elementary classroom featured a bulletin board, shown in the back, behind which was a cloakroom where students hung their caps, coats, and mittens. (Courtesy of Alcoa High School Alumni Association.)

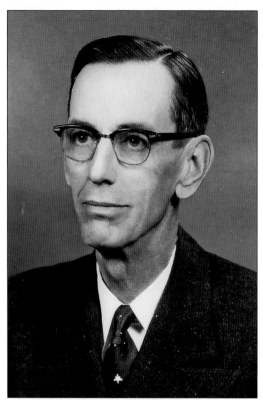

V.F. Goddard (left) served as Alcoa superintendent of schools from 1924 until 1957. He was also active in the Tennessee Secondary School Athletic Association (TSSAA), serving on its board of control and as president. He also served in the Tennessee House of Representatives. The high school football field is named in his honor. (Courtesy of Nelda French Kidd.)

Emmitt West (below, right) was a principal of Charles M. Hall School. He is pictured here during the 1949–1950 school year. Helen Harris (below, left) was a Hall High School teacher. After integration of the city schools, she taught English and French at Alcoa High School. She is shown here during the 1951–1952 school year. (Both courtesy of Alcoa City Schools.)

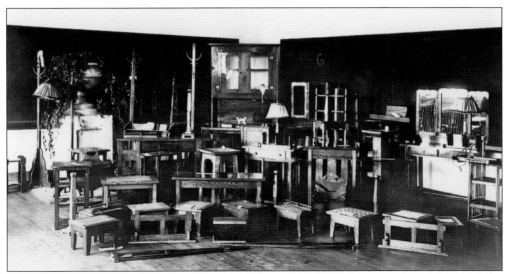

Student industrial arts products are shown inside a Hall High School classroom during the 1928–1929 school year. The Alcoa schools placed an emphasis on industrial arts instruction, then known as manual arts, in part to prepare students for employment at ALCOA. (Courtesy of Alcoa High School Alumni Association.)

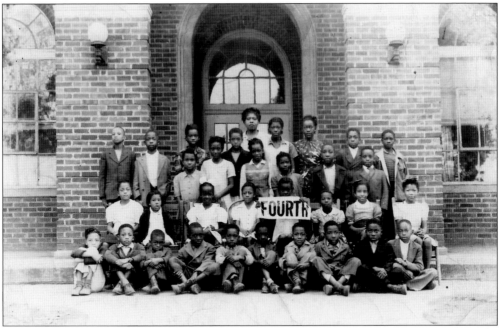

Pictured is the Charles M. Hall School fourth-grade class around 1940. Shown from left to right are (first row) Leslie Lundy, William Middleton, Eugene Cowan, Leroy Stewart, James Watts, Charles Davis, Griffin Dean, Ed White, Joe Dean, and Rudolph Henry; (second row) Shirley Tate, unidentified, Erma Miller, Lois Watts, unidentified, Equila Sykes, Carolyn West, and Doris Cureton; (third row) Henrietta Williams, Bertha Carr, unidentified, Betty Flowers, George Jenkins, and Lowell Love; (fourth row) unidentified, William Jenkins, Sally Webb, William Lundy, Mrs. Johnson, Bessie Smith, unidentified, Amos Keith, and unidentified. (Courtesy of Melvin Love; photograph by R. Lee Thomas.)

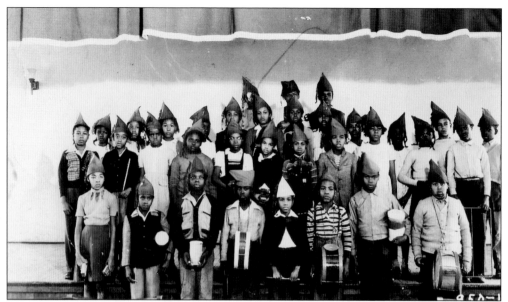

The fifth-grade class of Charles M. Hall School is pictured here around 1940 prior to the performance of the class play. Shown from left to right are (first row) Judy Anthony, unidentified, Raymond Henderson, unidentified, Robert West, Bill Grissom, unidentified, and Joe Jackson; (second row) Billie Joe Caldwell, Donald Travis, Betty Rose Byers, Zenobia Love, Adele Davis, Elaine Woods, unidentified, Ben Gaines, and three unidentified; (third row) Eleanor Robinson, Betty Hodge, Bobbie Jean Travis, seven unidentified, Pete Valentine, and unidentified; (fourth row) three unidentified. (Courtesy of Melvin Love.)

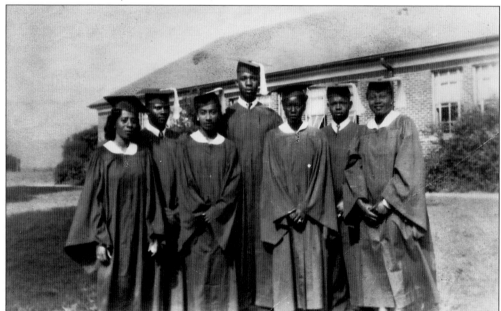

Hall High School seniors are pictured in 1950. Shown from left to right are Gwen Carr, Grady Knighton, Marion Humphrey, Garfield Crawford, Josephine Madison, Jack Carr, and Freddie Henderson. These students comprised a choral group known as the Lucky Seven. (Courtesy of Cecil Henderson.)

These Alcoa High School students are pictured with their industrial arts products in 1953. Shown from left to right are Joel Reeves, David Mills, and Tommy Frye. Their teacher was Carroll R. Campbell. (Courtesy of Alcoa High School Alumni Association.)

Hall High School's football homecoming queen, Carolyn Penson, is shown with her attendants in 1957. ALCOA's South Plant can be seen in the background. (Courtesy of Alcoa City Schools.)

Louise Fortescue operated a kindergarten before the Alcoa school system offered kindergarten instruction. Classes were held at Alcoa First United Methodist Church. (Courtesy of Margaret Fortescue Zircher.)

Claude Knight was a principal of Springbrook School. Students at Springbrook were not allowed to play in the creek or to venture beyond the creek from the playground. Failure to heed those rules was certain to result in a visit to the principal's office, where students were treated in a firm but fair and respectful manner. Knight was greatly admired by his students. (Courtesy of Tom Knight.)

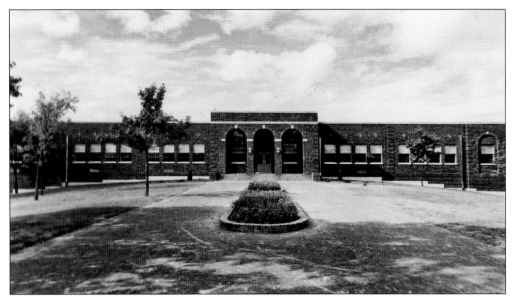

Alcoa High School is shown as it appeared from 1939 until 1964. The new school was featured in the *Alcoa News* published in Pittsburgh in January 1940. The building, designed by company employees, featured aluminum handrails, moldings, and windows and sashes, along with a state-of-the-art intercom system. Built on the foundation of a never-completed company clubhouse, the building was designed to hold a second story. (Courtesy of City of Alcoa.)

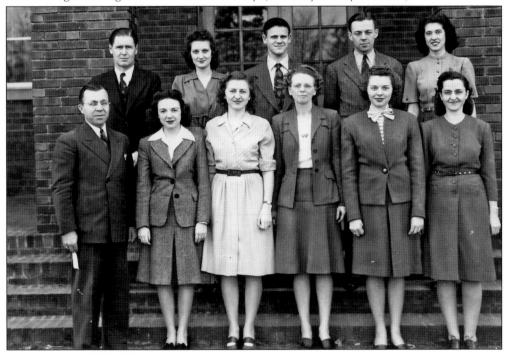

Pictured is the Alcoa High School faculty in 1946 or 1947. Shown from left to right are (first row) Principal G.W. Sneed, Ann Balch, Edith King, Charles Grace Hale, Juanita Fortner Morton, and Nannie B. Murrell; (second row) A.R. "Bob" Strang, Tommie Hitch Delozier, Henry Dickinson, George Lilly, and Willie Ruth Wright. (Courtesy of Alcoa High School Alumni Association.)

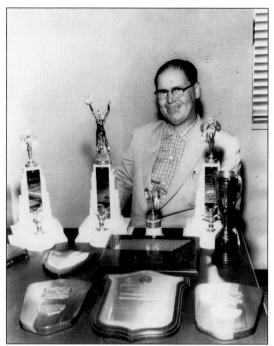

Longtime Alcoa High School band director A.R. "Bob" Strang is pictured here with multiple band awards received at the 1953 Bristol Band Festival. Strang believed in marching band music and taught his students marching precision. Alcoa's award-winning bands and individual performers were considered to be among the finest in the area. (Courtesy of Virginia Strang and Martha Strang Bibee.)

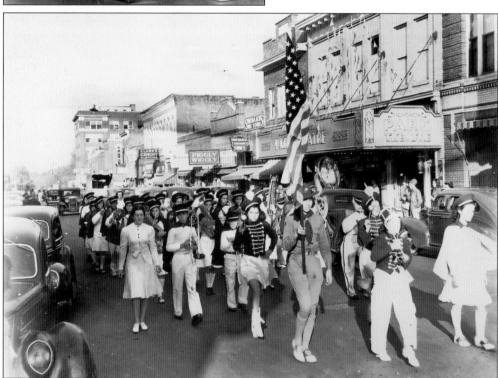

The Alcoa High Tornado Marching Band is shown in a parade on Broadway in downtown Maryville in October 1940. Park Theatre, shown in the background, is where Roy's Record Shop store was later located and is the only old building still standing in this block of Broadway. (Courtesy of Alcoa High School Alumni Association.)

Pictured are the 1958–1959 Alcoa High School majorettes. Shown from left to right are (first row) Sharon Garner and Sue Brewer; (second row) Helen Ware Flynn, Carolyn Tallent McClurg, Marsha Ware Brown, and Paula Roseburgh Marsh. (Courtesy of Virginia Strang and Martha Strang Bibee.)

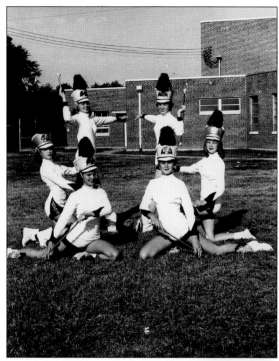

For decades, ALCOA has provided college scholarships to select children of employees. US Senator Lamar Alexander is pictured with his family in 1958, when he received his scholarship as a senior at Maryville High School. He is shown holding his Voice of Democracy trophy. Shown from left to right are sister Jane Alexander Carl, mother Floreine "Flo" Rankin Alexander, Lamar, sister Ann Alexander Schuler, and father Andrew "Andy" Alexander, safety director for ALCOA. (Courtesy of Alcoa, Inc.)

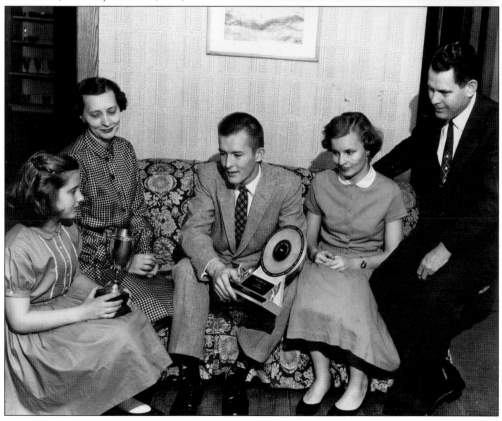

Pictured here are fifth-grade students Franklin Borden (left) and Kenneth Hagerty with their teacher Dorothy Dockter on the steps of Bassel School during the 1944–1945 school year. (Courtesy of Albert Dockter Jr.)

Fred Brown was a Hall High School teacher. He was the first African American to serve on the Alcoa School Board, having been elected to the board in 1969. (Courtesy of Thelma Brown.)

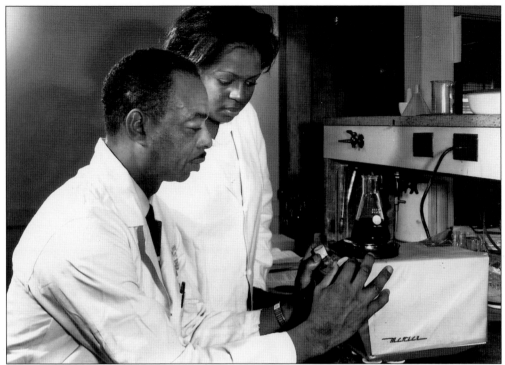

Pictured are longtime Hall High School teacher and coach Clarence R. Teeter Jr. (left) and student Ernestine Catchings. When the Alcoa schools integrated, Teeter was not hired as a teacher and was instead employed by the Oak Ridge National Laboratory Y-12 plant as a chemical analyst and to teach in the training and technology program. His Hall basketball teams, especially those of the early 1960s—which featured Wade Houston, C.A. Houston, and Tommy Woods—were among the best teams ever to play in this area. (Courtesy of Geneva Harrison.)

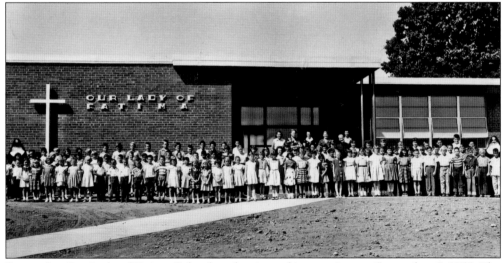

Pictured is Our Lady of Fatima School at the time of its opening on September 6, 1955. The 114-member student body is shown standing with Fr. Paul Clunan, the faculty, and the cafeteria managers. Bishop William Adrian of the Nashville Diocese blessed the school on November 27, 1955. (Courtesy of Our Lady of Fatima Church.)

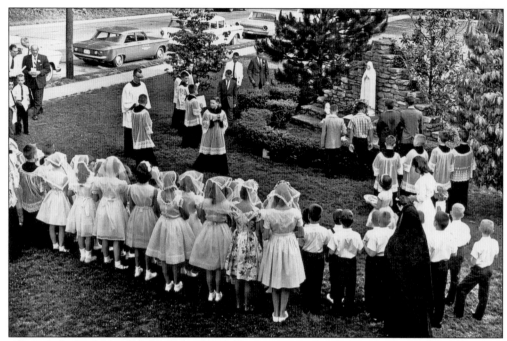

Above is the 1963 May Procession by the children of Our Lady of Fatima School and the crowning of the Virgin Mary at the grotto outside the church, a parish tradition. Below, Mary Caldwell places a crown of flowers on the Blessed Mother following the May Procession. Our Lady offered elementary instruction, and students transferred to the Alcoa city schools for junior high school. The school closed in 1970. (Both courtesy of Our Lady of Fatima Church.)

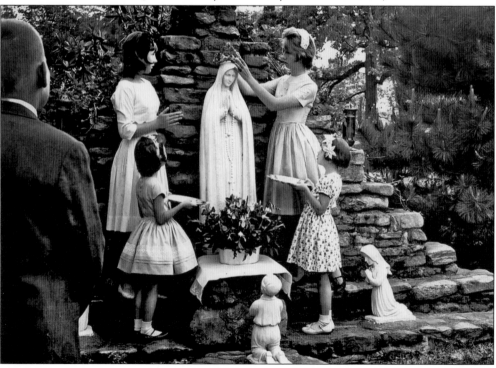

Three

SPORTS

Alcoa's school athletics have long been among the state's most successful teams. The Alcoa High School Tornadoes, initially known as the Red Tornadoes, began their championship ways in 1928 and 1929, when the football team went two years in Blount County play undefeated and unscored upon.

The Hall High School Blue Devils sent teams to three straight Negro state basketball tournaments from 1961 to 1963. The Blue Devils made it to the state championship game in 1962, losing 73-75 to Nashville Pearl. In 1961, the team lost, 60-68, in the opening game to Burt High of Clarksville, but Burt High went on to win both the state and national Negro high school championships.

Alcoa High School, with a student population that never exceeded 300 to 400 students, won two state basketball championships in 1959 and 1967, when there was no classification. Alcoa also finished second in 1965.

Athletics played a key role in the first partial integration of the schools in 1963. While some persons were critical, for various reasons, in bringing a small number of Hall High athletes and students to Alcoa High, Alcoa coach and, later, principal Bill Bailey believed Alcoa could build community support for integration as Alcoa residents witnessed these students' accomplishments.

Two Alcoa athletes broke important color barriers in the state. In 1965, Albert Davis became the first African American from Tennessee to be named to the All-Southern football team. Earlier that year, David Davis became the first African American to play in the Tennessee Secondary School Athletic Association (TSSAA) state basketball tournament.

Alcoa's spirit never shone finer than in 1964, when coach Vernon Osborne took his Tornadoes to the district basketball tournament. David Davis, at that time the only African American on the team, was told he could not play. Osborne responded that if Davis were not allowed to play, Alcoa would not play. Davis played with his teammates, and history was made.

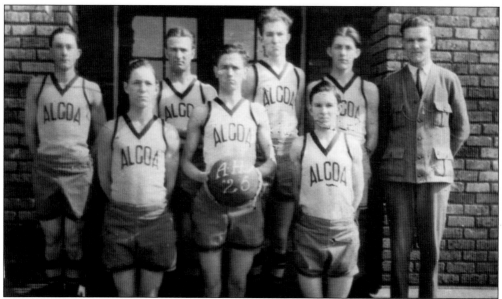

This photograph of the 1924–1925 Alcoa Red Tornadoes basketball team may be the oldest picture of an Alcoa High School sports team. Most of the players are unidentified. In the back row are Bill Linginfelter (second from left) and Don Bates (third from left), with Coach Pillard standing on the far right. (Courtesy of the Alcoa High School Alumni Association.)

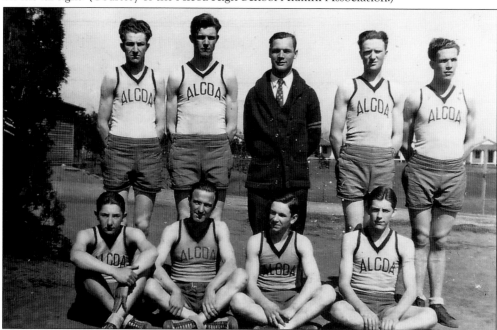

This picture is believed to be of the 1925–1926 Alcoa High School basketball team. Shown from left to right are (first row) unidentified, Bill Linginfelter, Cyril Brown, and unidentified; (second row) Don Bates, Charles Beightol, Coach Pillard, Lynn Miller, and Harold Beightol. The team is standing on the athletic field adjacent to Springbrook School, with Dalton Street in the background, before Springbrook gymnasium was built. (Courtesy of Alcoa High School Alumni Association.)

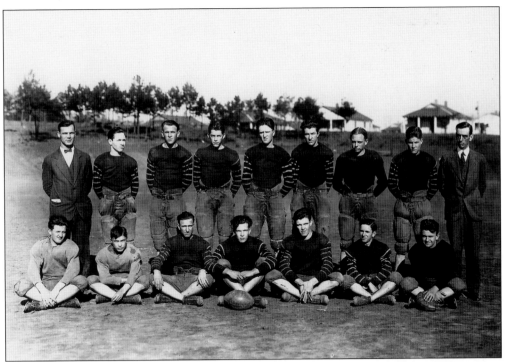

Pictured above is the 1925 Alcoa Red Tornado football team. Shown from left to right are (first row) Tommy Enis, Henry Settles, Bill Linginfelter, Harold Beightol, Charles Beightol, Cyril Brown, and George Buchanan; (second row) Coach Pillard, Bill Brown, Pat Burns, W.B. Emert, Lynn Miller, Don Bates, Ralph Teffeteller, Frank Hayes, and V.F. Goddard, superintendent of schools. Shown below is the team in offensive formation. The teams are pictured on the field, with Dalton Street in the background, before construction of Springbrook gymnasium. It is believed that, at this time, the teams played their games on an athletic field adjacent to Pistol Creek in the approximate area where Alcoa youth baseball games are now played. (Both courtesy of Alcoa High School Alumni Association.)

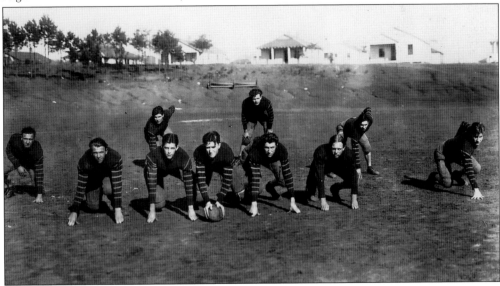

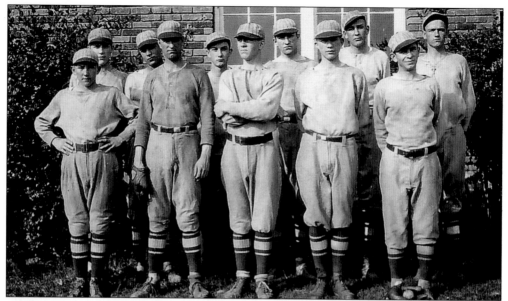

This picture is of either the 1925 or 1926 Alcoa High School baseball team standing in front of Springbrook School. Second from left in the first row is Bill Linginfelter. The other players are unidentified. (Courtesy of Alcoa High School Alumni Association.)

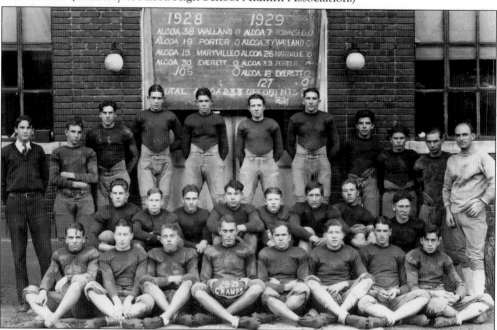

Alcoa's football teams were unbeaten and unscored upon in 1928–1929 Blount County play. Shown from left to right are (first row) Ronald Manges, T.A. Bowler, T.C. Gray, Horace Massey, Carl Teffeteller, James "Red" Sturgeon, Frank Linginfelter, and Ralph Watts; (second row) Clayton Davidson, Richard Studley, Joe Studley, Odie Helton, John Love, James Cochran, Johnny Feezell, and Robert Brumfiel; (third row) Walter Miller, Robert Byerly, Otto Turner, Homer Webb, Carson Webb, Bob Raulston, Charles Reed, Victor Bailey, A.C. Bean, Joshua Johnson, and coach A.E. Choate. (Courtesy of Alcoa High School Alumni Association.)

Alcoa High School's 1935 district champion basketball team members are, from left to right, (first row) Fern Webb, ? Dix, Reed Byrum, and unidentified; (second row) coach Jack Sherwood, ? Sutton, Alton Beaver, Harry McClurg, and Clarence Byrd. (Courtesy of Alcoa High School Alumni Association.)

Alcoa High School's 1938 district champion basketball team members are, from left to right, (first row) Elinor Pitts, Eloise Pitts, Mary Proffitt, Margaret Proffitt, Margaret Waters, and unidentified; (second row) unidentified, Sara Elizabeth McClurg, coach Dave Carson, June Gillespie, Wilda McFee, and unidentified. This team featured two sets of twins. (Courtesy of Alcoa High School Alumni Association.)

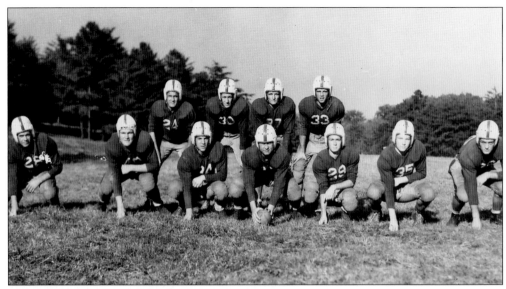

Pictured are Alcoa High School's 1944 varsity offensive starters, from left to right: (first row) John Price, Frank Boring, Glenn King, Tom Boyd, Jack Hancock, Eugene Prince, and Carl Vaughn; (second row) L.A. Campbell, Gene Reynolds, Kyle Reneau, and Charles Sneed. (Courtesy of L.A. and Virginia Campbell.)

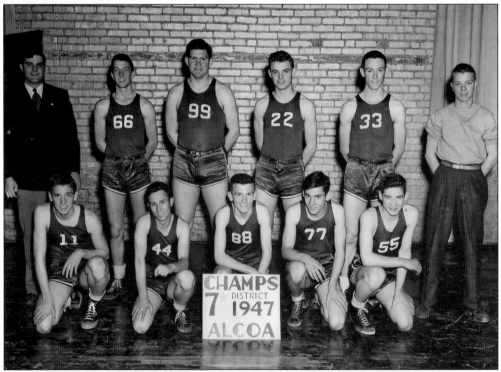

Alcoa High's 1947 district champion team members are, from left to right, (first row) Johnny Newman, Blaine Fox, Robert Campbell, Glenn King, and Steve Eubanks; (second row) coach John Wilburn, Bob Bates, Frank Boring, Ralph Dover, Kenneth Spencer, and Charles "Sonny" Murrin. (Courtesy of Alcoa High School Alumni Association.)

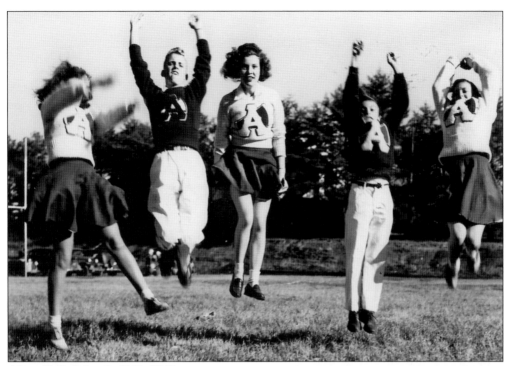

Alcoa High School's 1946–1947 cheerleaders, shown left to right, are Grace Coffey, Ray Hicks, Jewel Waldo, Sam Capps, and Dorothy Belcher. (Courtesy of Alcoa High School Alumni Association; photograph by W.H. Stevenson.)

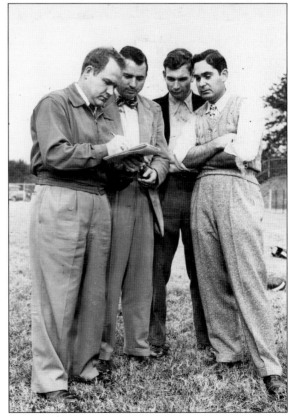

Pictured are Alcoa High School's 1950 football coaches, from left to right: Bill Bailey, James "Hycie" Newman, Vernon Osborne, and Clarence Byrd. This marked Bailey's and Osborne's first year as Alcoa teachers and coaches. (Courtesy of Doris Bailey.)

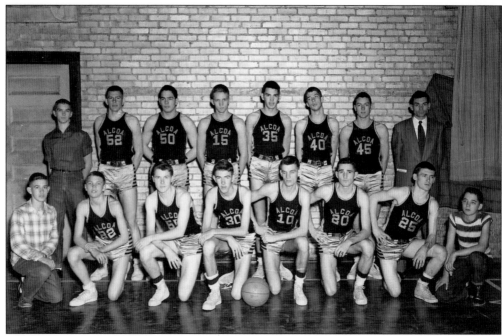

Shown is coach Vernon Osborne's first Alcoa High School basketball team. From left to right are (first row) Richard Patterson, Herman Thompson, Bobby Dover, Russell Cox, Earl Wolfenbarger, Bill Blair, J.L. Allen, and Dewitt Prater; (second row) Johnny Phipps, Vernon Boring, Bobby Woolf, Jimmie Vaughn, Jimmy Saunders, Donald Bates, Bill Linginfelter, and Osborne. (Courtesy of Alcoa High School Alumni Association.)

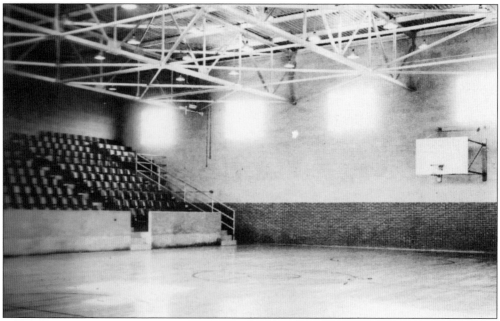

Hall High School's new gymnasium is shown in 1951. Prior to construction of the gymnasium, Hall High played its basketball games in the Community Building. (Courtesy of Alcoa City Schools.)

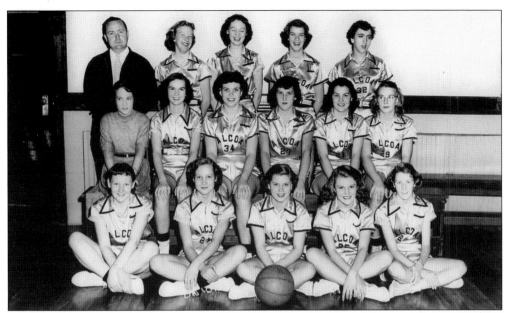

Bill Bailey also coached girls' basketball early in his career. He is pictured here with his 1952–1953 team. Shown from left to right are (first row) Pat Harmon, Helen Graves, Margaret Prichard, Loretta Henson, and Lorene White; (second row) Ann Thurman, Shirley Jones, Edna Key, Shirley Hill, June Dyer, and Denna Patterson; (third row) Bailey, Jean Love, Nancy Headrick, Nancy Murrin, and Jeanette Moody. Helen Graves Bledsoe was the only Alcoa basketball player, male or female, to average 20 points per game over four years. (Courtesy of Alcoa High School Alumni Association.)

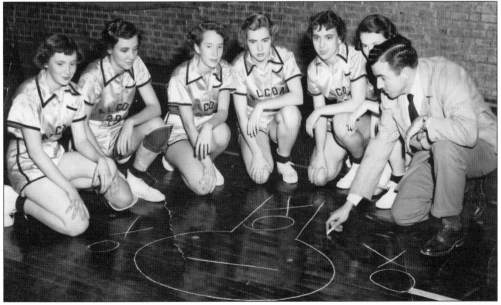

Coach James "Hysie" Newman diagrams a play for the Alcoa High School girls' basketball team in this early-1950s picture. Shown with their coach are, from left to right, Sue Capps, Barbara Witzel, Betty Massey, Carole Cox, Jeanette Moody, and Ruth Ammons. (Courtesy of Sue Capps Satterfield.)

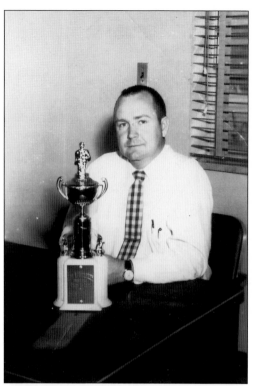

Football coach Bill Bailey is pictured with his 1954 Roy N. Lotspeich coach of the year trophy. Bailey's 91-32-6 record included a 29-game winning streak and undefeated seasons in 1954 and 1955. A member of the TSSAA Hall of Fame, only Bailey served Alcoa as a teacher, coach, principal, and superintendent. The high school football stadium is named for him. (Courtesy of Doris Bailey.)

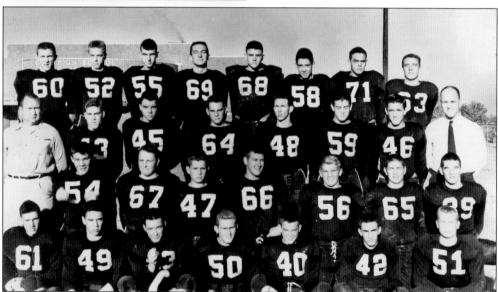

Pictured are the undefeated and untied 1954 Alcoa Tornadoes. Shown from left to right are (first row) Ted Marcum, Jim Bob Curtis, Tommy Yates, Dan Draper, Jim Fox, Billy Householder, and Robert Culberson; (second row) Don Green, Ted Snelson, Ronnie McClurg, Arnold Lane, Henry Oliver, Leonard Stinnett, and Hugh Phipps; (third row) coach Bill Bailey, Glenn Joines, Kenneth Joines, Dan Dyer, David Williams, Gerald Lambdin, Clinton Keller, and coach Gordon Brown; (fourth row) Richard Byrd, Henry Linginfelter, Jack Henry, Sam Sylvester, Verlan Long, R.H. Jewell, Bob Thacker, and Billy Duncan. (Courtesy of Alcoa High School Alumni Association.)

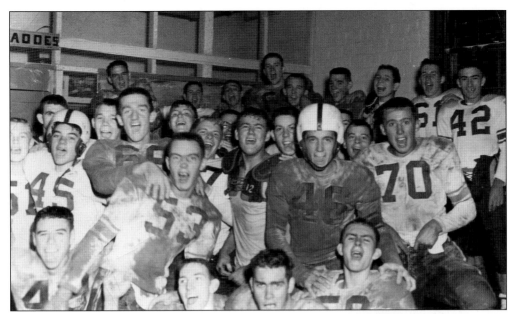

The jubilant Tornadoes are shown celebrating in the locker room after then-unknown Alcoa defeated mighty Kingsport Dobyns-Bennett 8-7 in the final game of the 1954 season. (Courtesy of Tommy Yates.)

In 1955, Tommy Yates became the second Blount Countian to be named to the All-Southern football team, and he was also named All-State and honorable mention All-American. His college career at Furman was plagued by injuries. (Courtesy of Tommy Yates; photograph by Proffitts Studio, portraits by Clark.)

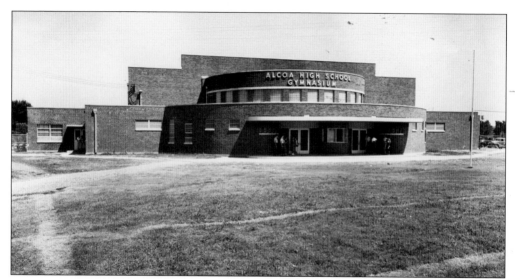

Alcoa High School's new gymnasium was featured on the cover of the TSSAA *Bulletin* in 1954. The best materials and equipment in modern school design were utilized in construction, including acoustically absorbent blocks for interior walls, an electrically operated folding partition, and modern dressing rooms for players and officials. Aluminum doors, window frames, and chairs were used. Helen Graves Bledsoe scored the first two points in the new gymnasium. (Courtesy of Vernon and Margaret Ann Osborne.)

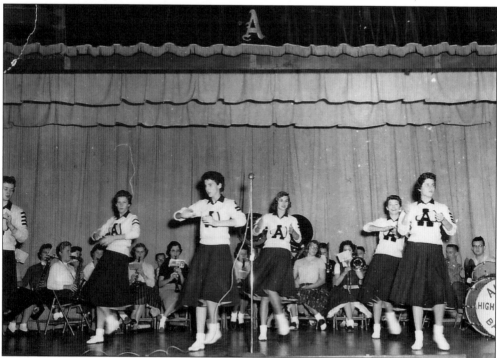

In this picture, Alcoa High School cheerleaders and pep band perform during the 1957–1958 year. A favorite cheer was "All the way, Big A, all the way." Shown from left to right are Jeannie Gregory, Wanda Davis, Linda Henry, Brenda Thacker, Nancy Baumgardner, and Judy Helton. (Courtesy of Nancy Baumgardner Burns.)

Shown are Hall High School cheerleaders Sylvia Porter, right, and Olivia Griffith, below, in 1957. During basketball games in the late 1950s and early 1960s, the Blue Devils often scored more than 100 points in a game. Because the scoreboard showed only two numerals, as the team approached 100 points, the cheerleaders would lead fans in cheering "We want the clock, we want the clock." (Both courtesy of Alcoa City Schools.)

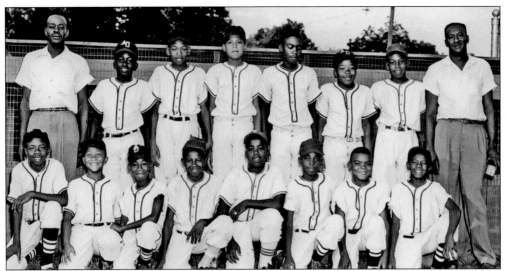

Pictured is one of the outstanding Alcoa Little League teams around 1956. Shown from left to right are (first row) Glenn Cook, Dwayne Shockley, Logan Hill, Alvin Barton, Paul Sudderth, Donnie Comas, Rufus Montgomery, and Walter Brabson; (second row) coach Tucker Reese, R.J. Miller, Wade Houston, Macky Bradford, Bud Walden, John Jones, C.A. Houston, and coach Morenza Knighton. Until integration of play, white youth competed in the American League, and African American youth played in the National League. (Courtesy of City of Alcoa.)

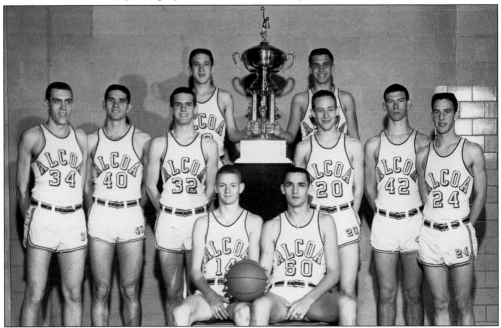

Alcoa High School's 1959 state champion Tornadoes finished with a record of 37-4. They defeated Meigs County 70-58 for the championship. Jim Riddick, Wayne Dixon, and Freddie Marsh were named All-State tournament, and Riddick was tournament MVP. Team members are, from left to right, (first row) Dixon and Riddick; (second row) Richard Holt, Don Phillips, Pete Summerville, Gerald Burns, Gary Hart, and Kermit Derrick; (third row) Marsh and Bucky McGill. (Courtesy of Vernon and Margaret Ann Osborne.)

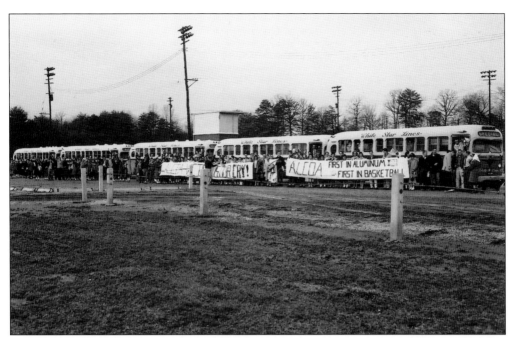

Alcoa fans are pictured before boarding White Star Lines buses to travel to the 1959 state basketball championship game. The banners read: "Alcoa victory is our cry," and "Alcoa, first in aluminum, first in basketball." (Courtesy of City of Alcoa.)

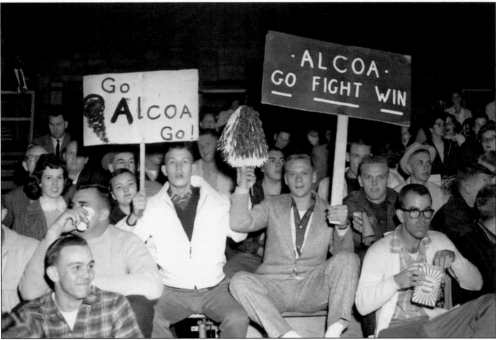

Alcoa fans cheered their team to victory at the 1959 state basketball championship game. Jerry Hodge, wearing a plaid shirt, is shown in the lower left corner. Shown holding signs are Barry Goodin (left) and Kenneth Burchfield. To the right of Burchfield is Henry Linginfelter, and eating popcorn in front is Charles Neely. (Courtesy of City of Alcoa.)

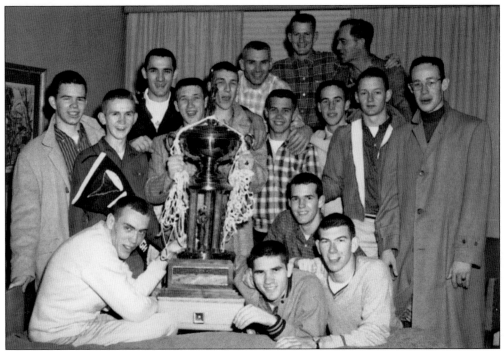

The Alcoa Tornadoes celebrated in their hotel room after the 1959 championship game. Shown from left to right are (first row) Richard Holt, Don Phillips, Pete Summerville, and Gary Hart; (second row) Jack Milton, Terry Stinnett, Jim Riddick, Freddie Marsh, Ray Allen, Bucky McGill, Kermit Derrick, Wayne Dixon, and Gerald Burns; (third row) coaches Vernon Osborne and Dick Abbott and scorer Vasco Lawson. (Courtesy of City of Alcoa.)

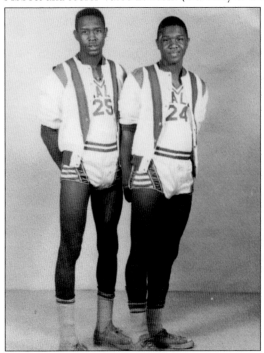

Shown are Tommy Woods (left), Hall High School class of 1963, and his brother, Larry Woods, Hall High School class of 1964. Tommy Woods had tremendous leaping ability and was one of the great players of this area. At East Tennessee State University, he set a conference record for rebounds in a game, and he later played for the Kentucky Colonels of the American Basketball Association before it merged with the NBA. (Courtesy of Quentin Anthony.)

Herman Thompson, Alcoa High School class of 1953, was Blount County's first All-State basketball player. He still holds the Alcoa record for points scored in a game (42). Among the all-time scoring leaders at the University of Tennessee, where he was team captain, Thompson was named to the 20-man All-Century team at Tennessee in 2009. (Courtesy of Vernon and Margaret Ann Osborne.)

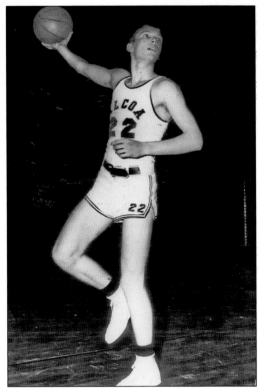

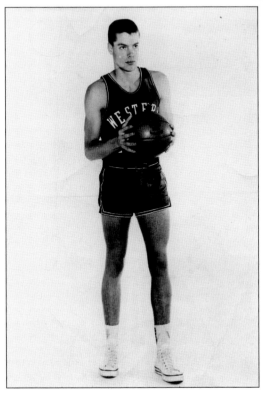

Jim Dunn, Alcoa High School class of 1958, had never played basketball before he transferred to Alcoa. Making the varsity team as a senior, he displayed such talent in one year that he made the University of Tennessee's undefeated freshman team in 1958–1959. He transferred to Western Kentucky, where he scored 50 points in three NCAA tournament games. In those games, he was assigned to defend future NBA legends Dave DeBusschere and John Havlicek. Dunn still holds two free-throw records at Western Kentucky. (Courtesy of Jamie Dunn.)

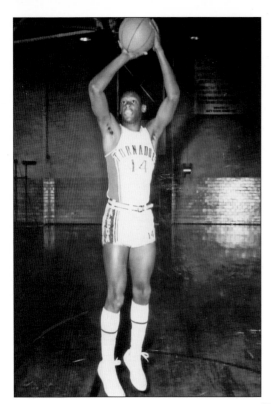

David Davis, Alcoa High School class of 1967, was twice named to the All-State team, and in 1967, he was an All-American honorable mention. Davis broke a historic color barrier March 8, 1965, when he walked onto the court of the state basketball tournament in Memphis, thus becoming the first African American to play in the TSSAA state tournament. A football standout as well, he played for the Green Bay Packers. (Courtesy of Vernon and Margaret Ann Osborne.)

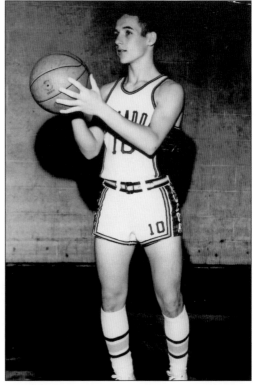

David Marsh, Alcoa High School class of 1967, was once rated the finest defensive player in the history of East Tennessee high school basketball. An excellent ball handler and shooter as well, he was named to three straight All-State tournament teams from 1965 to 1967. In 1967, he was named to the Prep All-America team. He would later serve as head coach at Alcoa High School. (Courtesy of Vernon and Margaret Ann Osborne.)

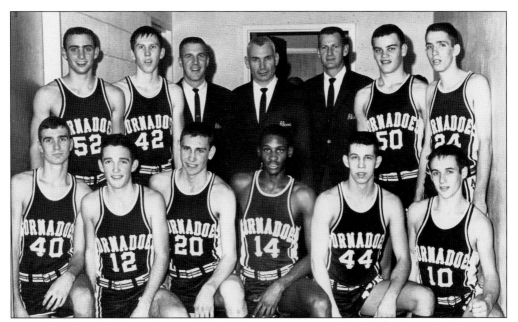

Pictured is the 1965 Tornado state basketball runner-up team. The "Mighty Mites," as they were called, started two sophomores and came from out of nowhere to make it to the final game against Murfreesboro before losing 33-41. They captured the fans' hearts in Memphis. David Davis, David Marsh, and Bill Padgett were named All-State tournament. Shown from left to right are (first row) Bill Woolf, Garry Godfrey, Bill Joines, Davis, Steve Cobble, and Marsh; (second row) Carroll Blalock, Larry Handley, coach Jack French, coach Vernon Osborne, coach Dick Abbott, Jerry Qualls, and Padgett. (Courtesy of Vernon and Margaret Ann Osborne.)

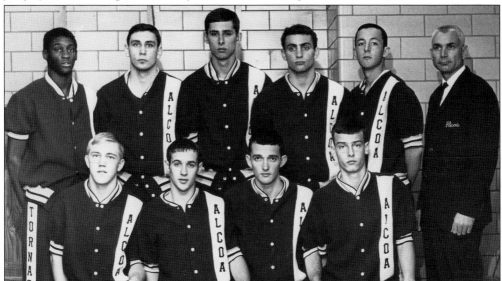

The 1967 Alcoa Tornadoes, 33-1, defeated Holston in three overtimes, 46-45, to win the state championship at a time when there was no classification. Shown from left to right are (first row) Jim Whittemore, David Marsh, Garry Godfrey, and Clayton Bledsoe; (second row) David Davis, Bill Joines, Gary Douglas, Carroll Blalock, Bruce Sipe, and coach Vernon Osborne. Blalock, Davis, and Marsh were named All-State tournament. (Courtesy of Vernon and Margaret Ann Osborne.)

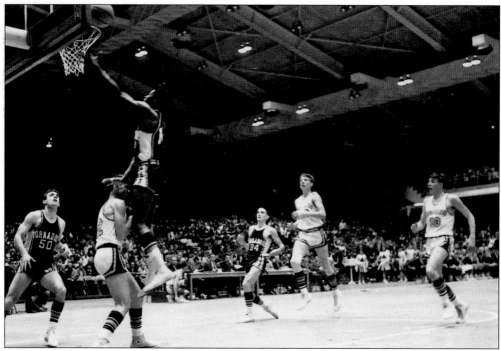

The 1967 state champion Tornadoes are shown in action in the state tournament against Collinwood. Tornadoes shown from left to right are Carroll Blalock, David Davis, and Garry Godfrey. In the third overtime of the final game, Godfrey intercepted a pass with nine seconds left. Following a pass from David Marsh, Davis launched a last-second turnaround jump shot that circled the rim twice and fell in to give Alcoa the win. (Courtesy of City of Alcoa.)

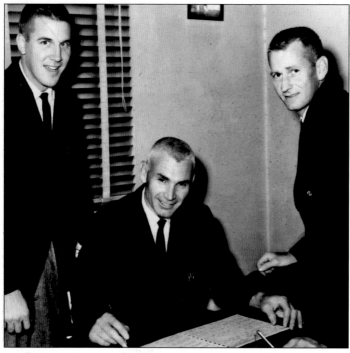

From left to right are Alcoa High basketball coaches Jack French, Vernon Osborne, and Dick Abbott. In 39 seasons, Osborne's teams won 20 district titles and 12 region championships, made 10 state tournament appearances, played in four more substate games, finished state runner-up twice, and won two state championships—all with a student body that never exceeded 300 to 400 students. When he retired in 1989, he ranked in the nation's top 10 in wins. (Courtesy of Vernon and Margaret Ann Osborne.)

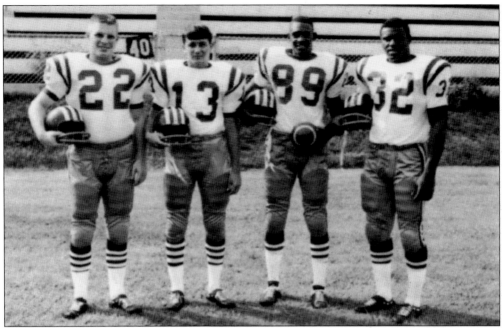

Shown above, from left to right, are Jim Palmer, Carson Keller, David Davis, and Albert Davis. The Davises went on to play for the Green Bay Packers and the Philadelphia Eagles, respectively. Below, Albert Davis is seen running the ball after a handoff from Clayton Bledsoe (number 11). Davis is still considered by many to be the finest high school football player they ever saw compete. In both his junior and senior seasons, he was named to the All-Southern and All-America teams, in addition to being named All-State. He broke a historic color barrier when named to the All-Southern team as a junior in 1965, becoming the first African American from Tennessee to be named to the team. (Both courtesy of Alcoa City Schools.)

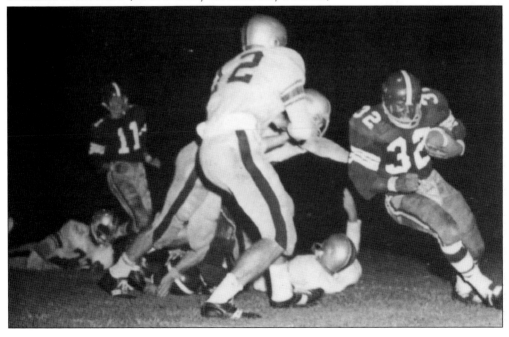

Ron Pittard was one of Alcoa High School's best athletes. He made All-State in basketball in 1970, when only one All-State team was selected. He was Alcoa's only player (in the era of separate freshmen teams) to make All-County three times. Still in the days before classification, the 1970 Tornadoes were ranked number one in the state in the final AP poll before being upset in substate play and were, perhaps, the best Alcoa team that did not win a state championship. (Courtesy of Vernon and Margaret Ann Osborne.)

Tim George was a talented Alcoa High School athlete who emerged as a receiver at Carson-Newman College. At Carson-Newman, he led his team to the National Association of Intercollegiate Athletics (NAIA) national championship in 1972 and was named game MVP. He played for the Cincinnati Bengals in the NFL and, later, in the World Football League. (Courtesy of Tim George.)

Four

HOMES, BUILDINGS, AND PLACES

Each community is home to places that stir the memory—an old school or playground, a park, and homes or other buildings with storied pasts.

Alcoa has such places: from Springbrook Park, with its brook and king and queen's chair rock formations, to the Charles M. Hall School building to Springbrook gymnasium and "the bridge" to the Springbrook ball field that was home to Thursday evening bonfires on nights before football games with Maryville. These places are alive with memory.

Most of the homes of old Alcoa were simple ones, having been built by ALCOA or Babcock Lumber Company for workers. These homes, however, have their own stories to tell. Most of the 950 homes built by ALCOA and 200 homes built by Babcock remain home to residents and monuments to bygone days.

Of the finer old homes, there are few remaining: Mayor C.L. Babcock's home and the other Babcock executive homes on Poplar Street, V.J. Hultquist's home, the "city manager home," and the other former ALCOA executive homes located along Springbrook Road.

The city manager's home, as it has been known for many years, is located on property that was part of a 300-acre conveyance to ALCOA in 1919. The stately home—often used for Alcoa High School yearbook photographs—was constructed by the company to house executives. The first person to live there was E.M. Chandler, manager of the fabricating division. Although the home did not appear on county tax rolls until 1934, Chandler's grandson says that it was built in 1924–1925 and that the Chandler family moved into the home on March 3, 1925.

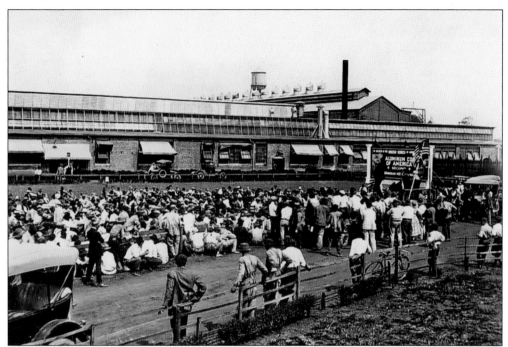

A sense of place and community became attached to ALCOA's West Plant, unlike the other two plants, due in part to its closeness to the Springbrook community, including its location adjacent to Alcoa High School. This picture portrays a World War I war bond rally at the West Plant. (Courtesy of Alcoa, Inc.)

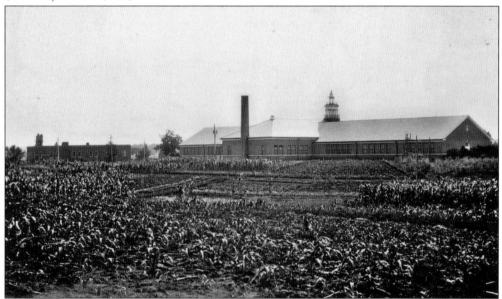

Shown here are community gardens located behind Charles M. Hall School in the 1930s. Community gardens also were located in other areas of Alcoa. The program was begun in 1932 under the direction of city manager V.J. Hultquist and was designed to provide an avocation for workers and cash income for youth, as well as to promote home beautification and provide food for families. (Courtesy of Alcoa, Inc.)

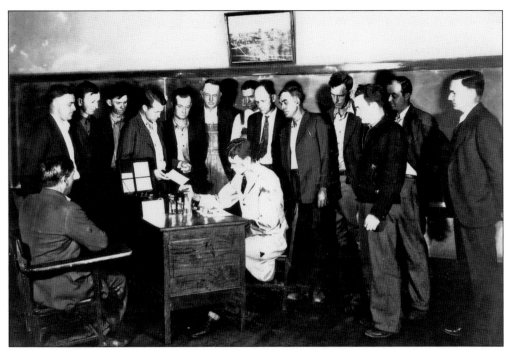

The community gardening program included agricultural education components for students and adults. Shown here are adults participating in soil testing at Springbrook School around 1934. Seated at the desks are an unidentified person and Mr. Bass (right), a science teacher. Shown standing from left to right are Claude Tallent, John Paul Green, Luther Hamilton, Claude Belcher, Swede Rose, Reed Phillips, ? Webb, unidentified, ? Evans, Fred Williams, Vic Reneau, and two unidentified. (Courtesy of Alcoa High School Alumni Association.)

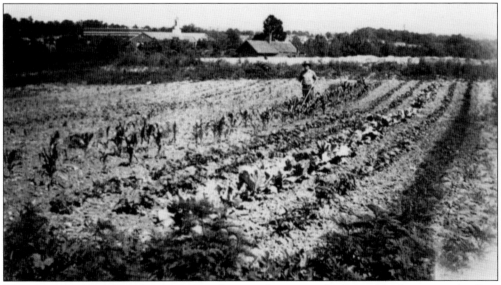

The community gardens shown in this photograph were in the Springbrook community. Rev. Fred Brown is shown holding the plow. Springbrook School is visible in the background. In 1933, the program had 143 participants and canned 14,016 quarts of vegetables for the winter months. (Courtesy of Alcoa High School Alumni Association.)

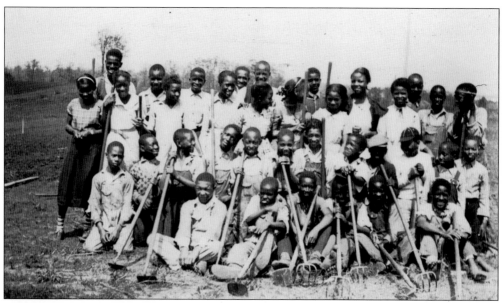

Charles M. Hall School students are shown in 1936 at work in the community gardens. The community gardening program included agricultural instruction as part of the city school curriculum. (Courtesy of Alcoa High School Alumni Association.)

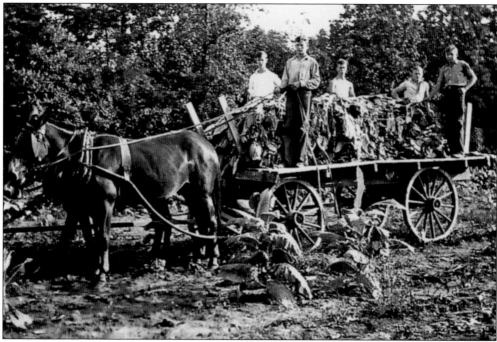

Springbrook School students are shown in 1936 after having loaded a mule-drawn wagon with recently cut and spiked tobacco. (Courtesy of Alcoa High School Alumni Association.)

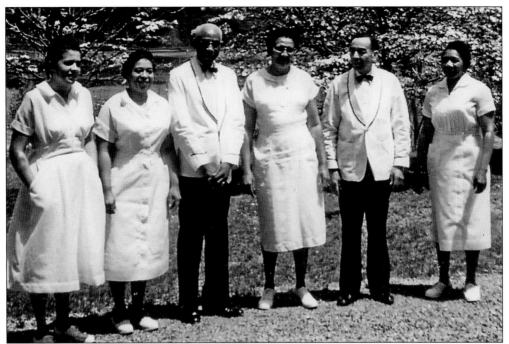

Workers at ALCOA's Scona Lodge in the mid-1950s are, from left to right, Cordia Mynatt, Thelma Jones, Clarence Teeter Sr., Angella Griffin, Tom Isom, and Hattie McGhee. (Courtesy of Thelma Jones.)

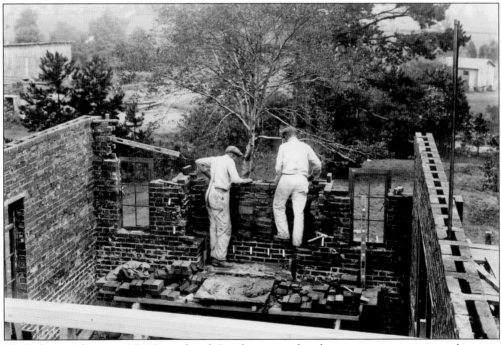

V.J. Hultquist's home at 1533 Springbrook Road is pictured under construction some time between 1921 and 1925. Brick masons Andy Carr, left, and Chester McMahan are shown working on the home's fireplace and double-brick walls. (Courtesy of Alcoa, Inc.)

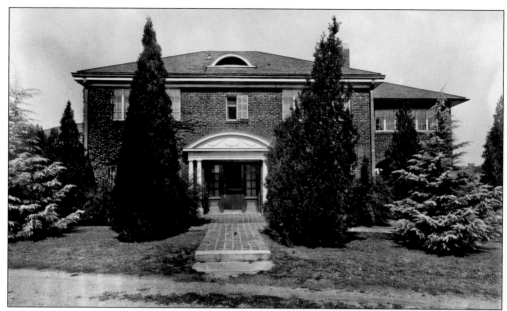

This home was constructed by ALCOA for E.M. Chandler, superintendent of fabricating operations, in 1924 and 1925. He and his family moved in on March 3, 1925. At that time, Springbrook Road did not extend north beyond the Chandlers' driveway. Alcoa High School yearbook photographs were often taken inside this stately home. In 1958, the home was sold to the city for use as the city manager's residence. The city sold the property in 1984. (Courtesy of Alcoa, Inc.)

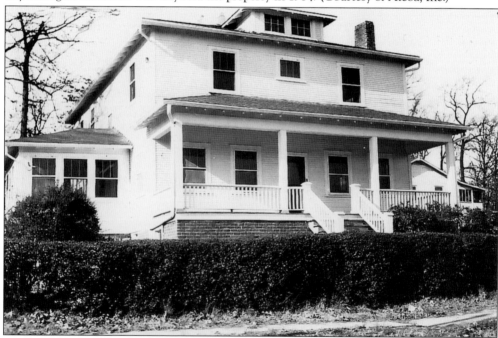

Pictured is the home of Alcoa's first mayor, C.L. Babcock, on Poplar Street around 1953. Babcock was president of Babcock Lumber Company, and he served as mayor from 1919 to 1925. During that time, his brother, Everett Vose Babcock, served as mayor of Pittsburgh. The home, built around 1916, is now owned by Albert Dockter Jr. (Courtesy of Albert Dockter Jr.)

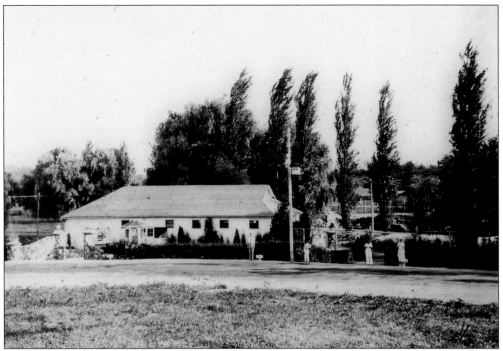

Shown above is the original bathhouse and entrance to Springbrook Pool in the 1930s. Many of the city's park and recreation improvements, including the pool, were constructed during periods of ALCOA unemployment, when the city would hire company workers. The pool opened on June 13, 1931. Pictured below around 1933 is the old diving platform with the paddle wheel and the "red top" high diving board. (Above, courtesy of Don Bledsoe; below, courtesy of Dyran Bledsoe.)

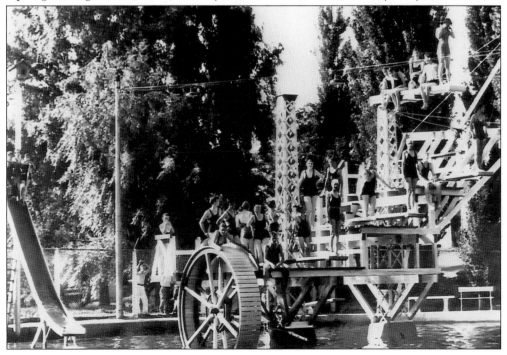

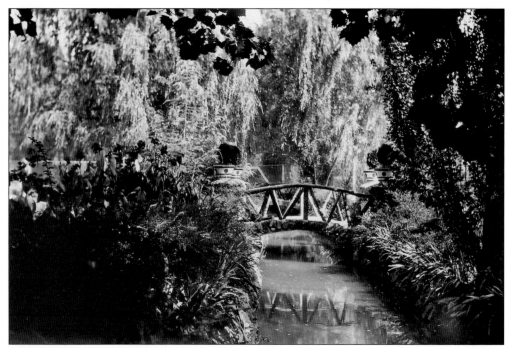

Springbrook Pool's lagoon and bridge (above) and picnic grounds (below) are shown in 1935. V.J. Hultquist, city manager and company construction supervisor, conceived, designed, and supervised construction of the pool and grounds. Water shows featuring synchronized swimming were performed at the pool. (Above, courtesy of Alcoa High School Alumni Association; below, courtesy of City of Alcoa.)

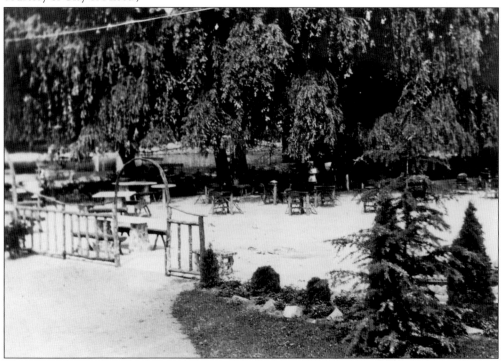

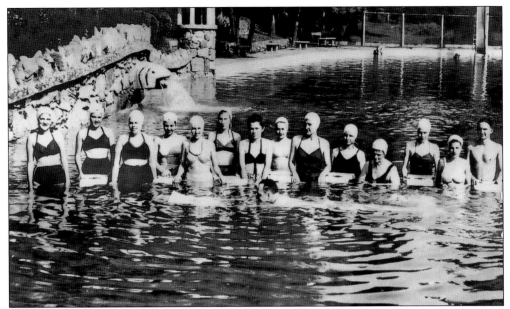

In the picture above, Red Cross lifeguard students hold flotation devices in the 1930s. The fish-head fountain is seen in the upper left of the picture. V.J. Hultquist personally constructed the fish head in his home workshop. The fish head's eyes were lit in green at night. In the picture below, swimmers enjoy the merry-go-round, also in the 1930s. The stone towers housed large floodlights to illuminate the pool at night. On Friday evenings, band concerts were performed in the area behind the stone wall. In the 1953–1954 season, more than 32,000 attended the concerts. (Above, courtesy of City of Alcoa; below, courtesy of Don Bledsoe.)

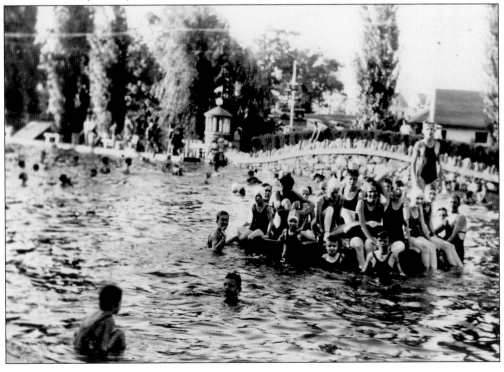

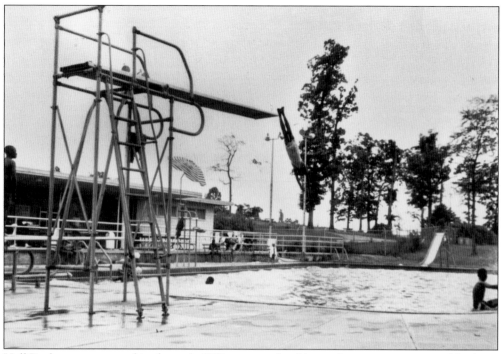

Hall Pool was constructed in the early 1950s to provide additional separate recreational facilities for African American citizens. The pool was located in what was then referred to as Hall Park, near the present site of the Martin Luther King Jr. Community Center. The pool has been demolished. (Courtesy of City of Alcoa.)

Pictured around 1951 is "the bridge," as it is referred to in Alcoa, where Faraday Street meets Darwin Street and Vose Road. From left to right are Carol Thomas Cox, Betty Ann Beaver Pritchard, June Dyer Trbovich, Carolyn Dyer Butcher, and Donna Blair Toomey. Generations of Alcoa students have painted graffiti celebrating athletic victories, birthdays, marriages, and other events and themes on the bridge. (Courtesy of Patsy Cook Bridges.)

Members of the Alcoa Garden Club are shown in this picture. They are seen planting a weeping cherry tree in Springbrook Park in 1953 in memory of Mrs. R.C. Laurell, a charter member of the club. In the center is Mary Lee Hord. The other members are unidentified. Alcoa was designated a Tree City in 1986. (Courtesy of City of Alcoa.)

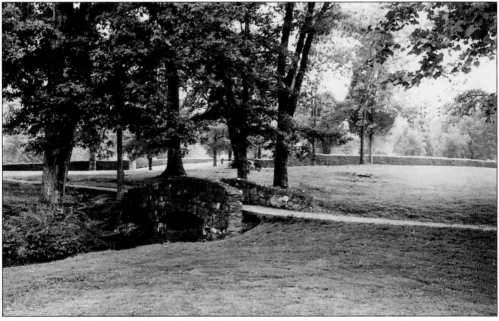

The creation of Springbrook Park followed ALCOA's commitment to provide one acre of park per 100 residents. Shown here is the stone bridge that crosses the brook for which the park is named. The bridge provided access to the former Springbrook School grounds. (Courtesy of David R. Duggan.)

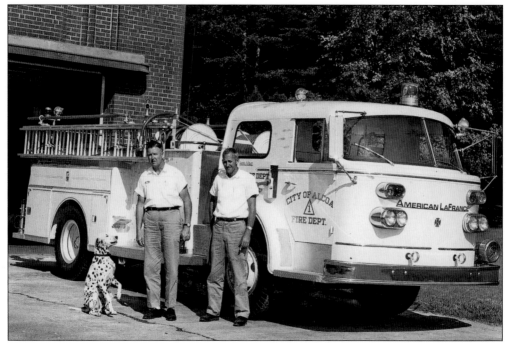

Shown are Alcoa firemen Earl Daffron, left, and Clarence Story, the chief. Also pictured is the department's dalmatian mascot, Bosco. They stand alongside the city's new American LaFrance fire engine purchased in 1967. Story was the city's first full-time fire chief. (Courtesy of Alcoa Fire Department.)

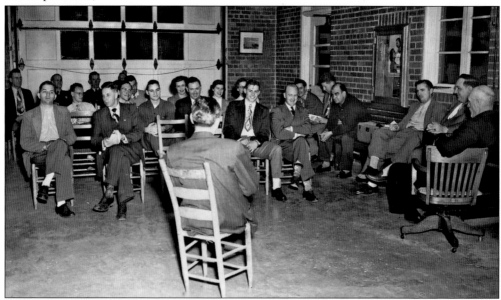

The Alcoa Volunteer Fire Department meets in the late 1940s. At this time, Alcoa depended exclusively on a volunteer force for fighting fires. The first paid fireman was Elmer Trentham, and he was succeeded by Epheriam D. Chambers, who lived with his family in an upstairs apartment in the fire hall. The fire hall was a popular gathering spot for community leaders. (Courtesy of Col. Duff "Zoe" Manges.)

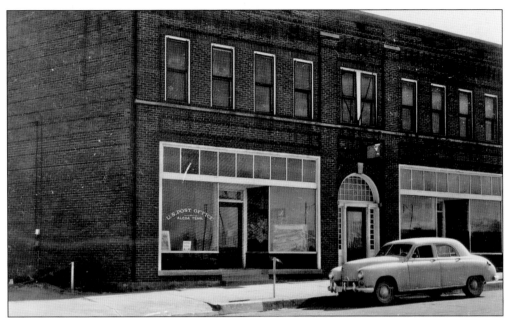

Alcoa's first post office was located in the Birchfield building on Lincoln Road. It is shown here in the 1950s. The post office opened on July 23, 1920. Benjamin Goyne was the first postmaster. BB's Café was also located in the building, which was later incorporated into Walker Supply Company. The building has since been demolished, and CVS Pharmacy is located on the site. (Courtesy of City of Alcoa.)

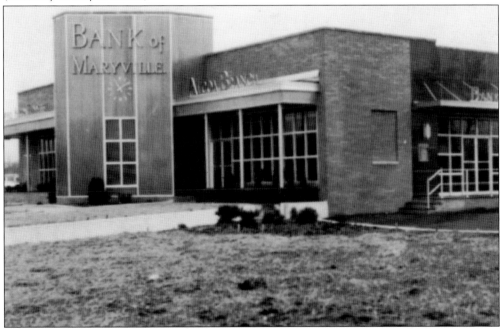

Alcoa's new post office, located in the left portion of this building, opened in 1958, and a branch of the Bank of Maryville was also located there. The post office remains on this site, but its location was reconfigured when the new post office and a First Tennessee Bank branch office were constructed. (Courtesy of City of Alcoa Schools.)

Alcoa Highway in the late 1940s was a two-lane road. In the picture above, the two-story white frame home of H.C. Woolf, of Bond-Woolf Company (successor to Babcock Lumber Company) can be seen to the center left. The picture below is a closer view of the home around 1950. The home, constructed in 1938 and 1939, was purchased by WATE-TV executive Russell W. Hillis in 1969 and became known as the Hill House. Pellissippi Parkway now extends through the former location of the home. Construction of the parkway prompted the Hillises to move the home 900 yards in 1988. (Above, courtesy of City of Alcoa; below, courtesy of Patsy Cook Bridges.)

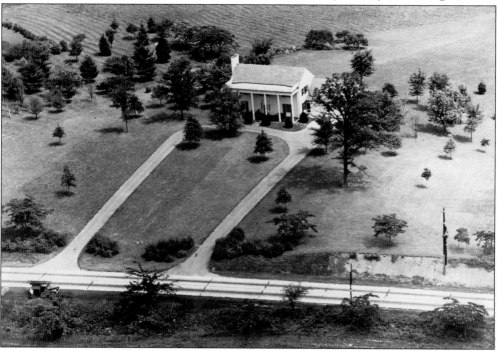

Five

COMMERCE

Alcoa never had a downtown area. ALCOA dominated area commerce, and the retail establishments that followed—grocery stores, gasoline stations, restaurants, and so forth—tended to be located along Wright Road in Springbrook, Hall Road as it was extended, Lincoln Road, and the new Knoxville Highway (Alcoa Highway), commercial growth along the latter corridor, including Knoxville's McGhee Tyson Airport, having exploded.

The smaller commercial establishments, most of which are now gone, gave rise to their own community ties and memories: Blue Circle Restaurant, the Commercial Building, Dean's Store, the Dreamland, J and K Superstore, Lambdin Brothers Grocery, Nicely's Grocery, Roy Howard's radiator shop, Davis Sundries ("Sam's"), Shorty Gibson's Amoco, Stubblefield Dry Cleaners, and Roy Witzel's Texaco station—all gone now, though some of the buildings remain and house other businesses.

Springbrook and Alcoa High students recall Sam's, later Birdwell's—its chili dogs and a small fountain drink for a quarter, cherry Cokes and the Tornado, which contained a mixture of each flavor on the fountain—and stopping by Nicely's Grocery after school and receiving butcher Junior Reagan's warm smile and perhaps a bit of bologna sliced from a roll and placed on a cracker, sometimes free of charge.

Hall students recall the walk past the Commercial Building under the watchful eye of barber Melvin Love and Mrs. Welch offering treats from the sweet shop. Students who lived in Oldfield walked on, the lucky ones stopping at the J and K Store. Then they passed Quickie's, Dean's Store, Leo Howard's shop, and the Dreamland until they reached home, where chores and homework preceded play until dark.

These businesses are gone now, but not so the memories.

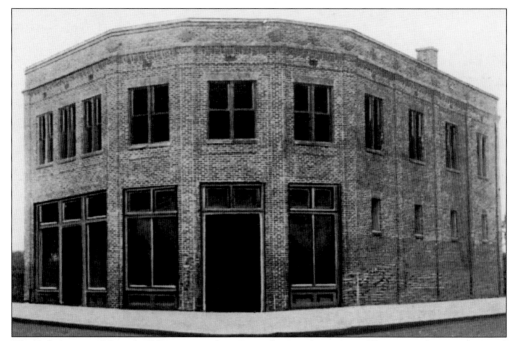

The Johnson and Law building opened on Lincoln Road in 1920. The general store operated on the commissary plan and featured groceries, clothing, fresh and cured meats, and general merchandise. Later, J and K Superstore was located here. In the 1940s, youths skated to jukebox music upstairs. (Courtesy of Alcoa, Inc.)

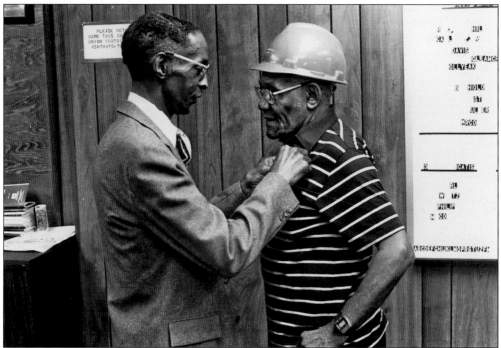

ALCOA dominated local commerce. Roy Howard (left) places a 50-year service pin on Eldie "Jabo" Hill. Howard was also a member of the company's 50-year club. (Courtesy of Jackie Hill.)

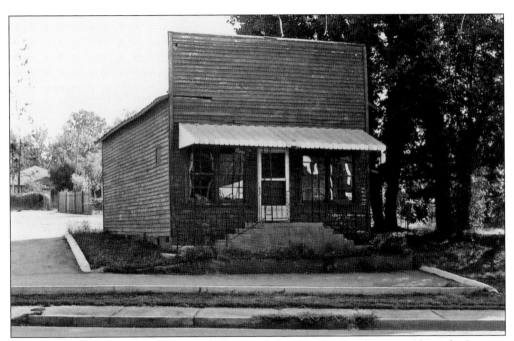

This building, formerly located on Wright Road, housed the first location of Nicely Grocery Store. It was later home to a beauty salon. All that remain today are the steps to the building. (Courtesy of Sandra Warwick.)

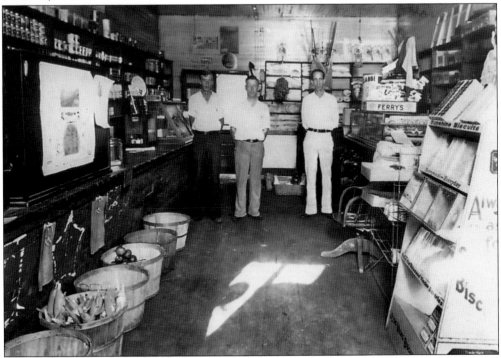

This picture of the original Nicely Grocery Store was taken inside the building above. From left to right are Thad Crompton, clerk and deliveryman; A.C. Nicely, owner; and Eugene Wells, a customer. (Courtesy of Sandra Warwick.)

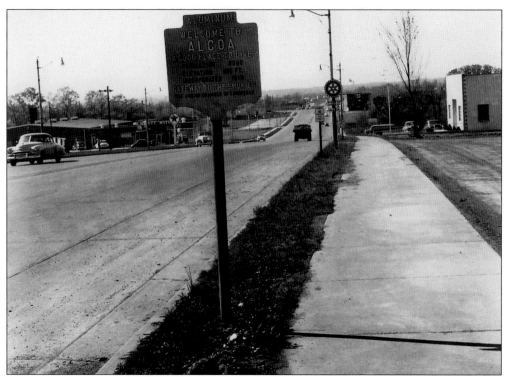

Shown in this picture is the old municipal boundary marker on Hall Road when McNutt Motors (left) was located there. The Costner-Eagleton Ford dealership would later be located in the McNutt building. The white building on the right is the old Bell Telephone company office. Commercial establishments soon lined Hall Road after the opening of this extension in 1945. (Courtesy of Don Bledsoe.)

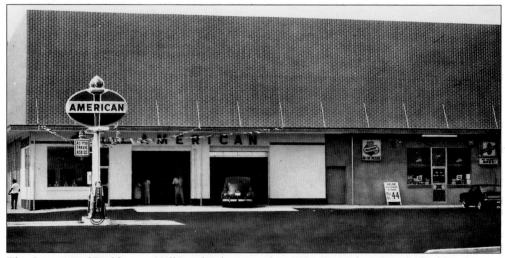

The Commercial Building on Hall Road is shown in the 1960s. Opened in 1919, the building housed a drugstore, meat market, dry goods store, and grocery store. A barbershop and a poolroom were in the basement. A school was originally located on the second floor. In 1968, due to Commissioner Stone Carr's efforts, the building became, perhaps, the first structure in America named for slain civil rights leader Dr. Martin Luther King Jr. (Courtesy of Don Bledsoe.)

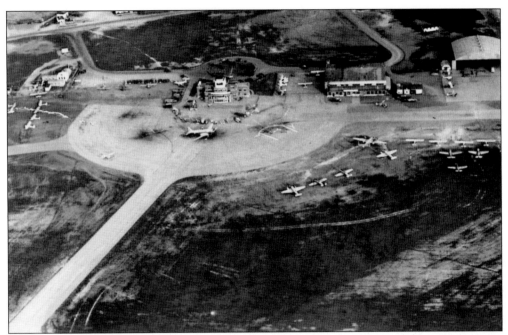

Shown in this aerial photograph is Knoxville's McGhee Tyson Airport on Alcoa Highway in the late 1940s. Alcoa Highway, still a two-lane road in the picture, is in the upper background. (Courtesy of Patsy Cook Bridges; photograph by Cook's Aerial Photo Service.)

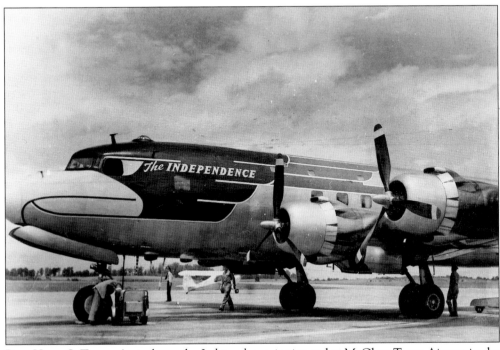

Pres. Harry S. Truman's airplane, the *Independence*, is pictured at McGhee Tyson Airport in the late 1940s. (Courtesy of Patsy Cook Bridges; photograph by Cook's Aerial Photo Service.)

Shown are Cook's Aerial Photo Service founder William P. "Bill" Cook, left, and Colonel Taylor, president of Supreme Foods, in the late 1940s. (Courtesy of Patsy Cook Bridges; photograph by Cook's Aerial Photo Service.)

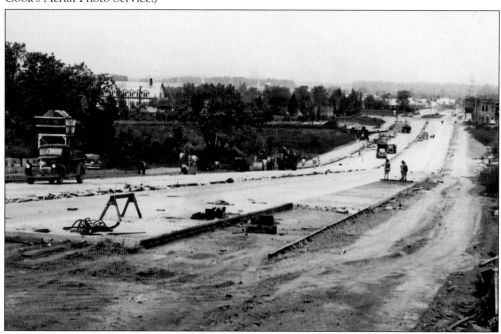

The Hall Road extension to Maryville is under construction in 1944. The Mule Barn is in the left background. Prior to construction of this road extension, access to Maryville was via Lincoln Road and Aluminum Avenue. Extensive commercial development followed the road construction. (Courtesy of Alcoa, Inc.)

Nicely's Grocery Store, on the corner of Vose and Wright Roads, is shown around 1961. Residents could buy groceries on credit, and the store offered home delivery, even for a single item. Masonic lodge meetings were held upstairs. (Courtesy of Alcoa City Schools.)

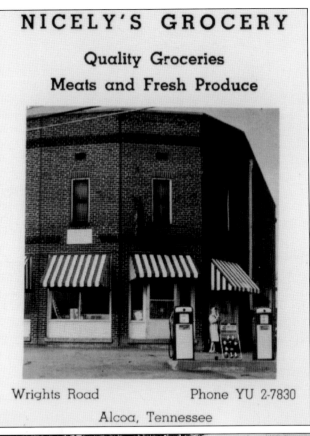

NICELY'S GROCERY

Quality Groceries
Meats and Fresh Produce

Wrights Road Phone YU 2-7830

Alcoa, Tennessee

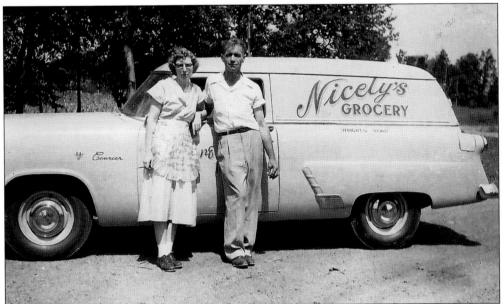

Imelda and Helmer Nicely stand alongside the Nicely Grocery Store delivery truck in the 1950s. The store offered fresh meat and produce in addition to a full line of grocery items. (Courtesy of Sandra Warwick.)

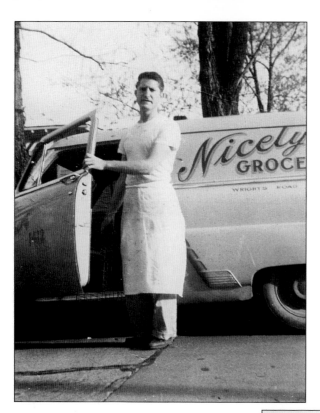

Longtime Nicely butcher Otha "Junior" Reagan stands beside the delivery truck. Families' supper plans were often dependent on what Reagan was cutting on a given day. (Courtesy of Sandra Warwick.)

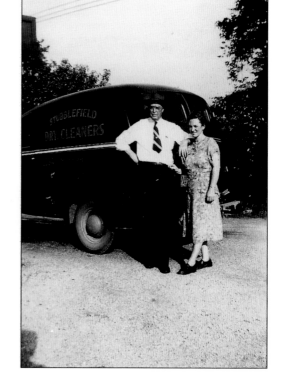

Stubblefield Dry Cleaners proprietors L.C. Stubblefield and Maude Davis Stubblefield stand beside their delivery truck in the parking lot of their business on Wright Road in the late 1940s. (Courtesy of Cliff Stubblefield.)

Pictured at right, barber A.R. Carter stands outside Carter's Barber Shop when it was located in the rear of Nicely's Grocery Store. Shown in the picture below in 1954, Carter told the Alcoa High School football players and band members that he would give free haircuts if the Tornadoes went undefeated, which they did. Collecting their haircuts, from left to right, are Tommy Yates, Carter, Bobby Thacker, Richard Byrd, R.H. Jewell, Billy Householder, and Arnold Lane. Hugh Phipps is seated in the barber's chair. (Both courtesy of Pete Carter Jr.)

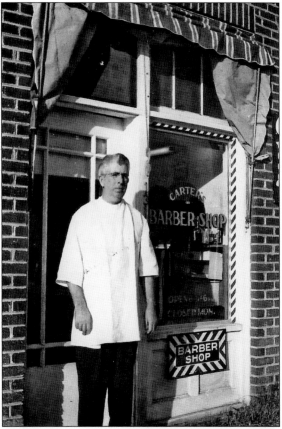

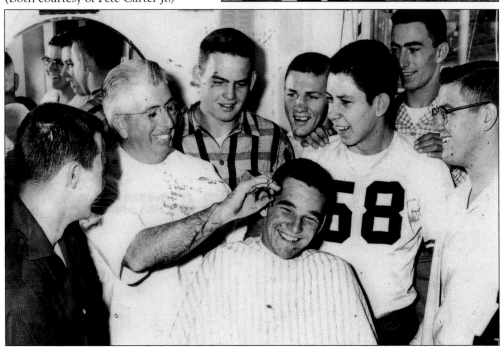

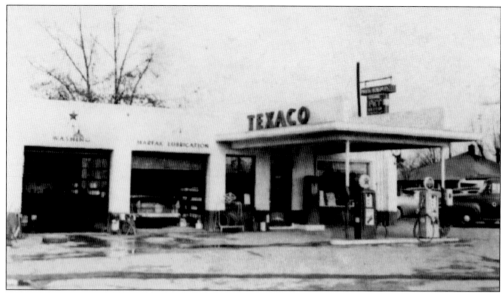

Roy Witzel's Springbrook Texaco station was on Wright Road in the building where Bread of Heaven restaurant is now located. Davis Sundries was originally on the right side of the building. (Courtesy of Alcoa City Schools.)

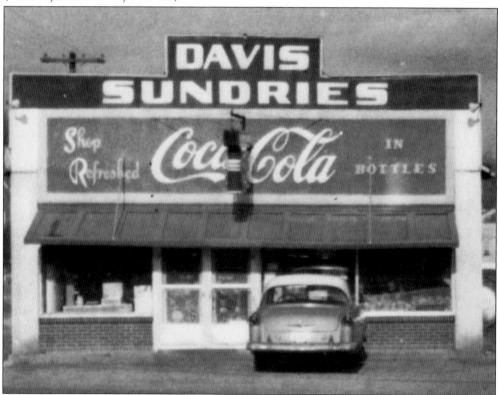

Davis Sundries is shown at its second location around 1965. Sam's featured a lunch counter and was a favorite hangout for Alcoa High School students. Davis's business was purchased by Glenn Birdwell in 1967. (Courtesy of Alcoa City Schools.)

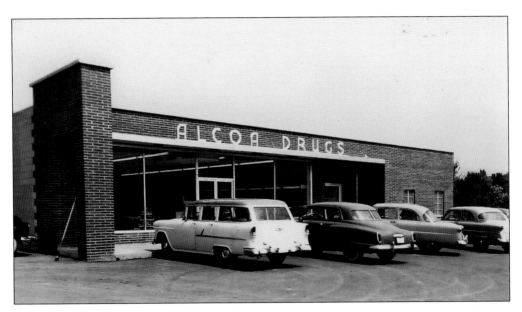

Most Alcoa residents had their prescriptions filled at Alcoa Drugs, pictured above, on Hall Road (once known as New Alcoa Highway). The business was located behind the Burchfield building, which was incorporated into Walker Supply Company. CVS Pharmacy now sits on the site. For many years, Dr. Joe Henderson's medical practice was also located in the building. Below is pharmacist Clifton "Tommy" Thomas. (Both courtesy of Clifton Thomas.)

Glenn Birdwell acquired Davis Sundries in 1967 and opened Birdwell's Restaurant, shown above. The restaurant was a favorite Alcoa dining place for many years, especially for breakfast and lunch. The business featured lunch specials and Bird burgers. In the photograph below, Birdwell stands behind the counter. A favorite employee of Birdwell's customers was longtime Alcoa resident Myrtle Cobble. (Both courtesy of Joe Birdwell.)

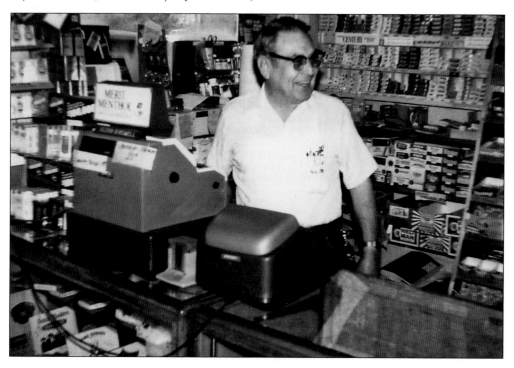

Six

ACTIVITIES, INDIVIDUALS, AND FAMILIES

The lifeblood of any community is its families and individuals within the community who give it life and establish and sustain its values, customs, and traditions.

Alcoa's population has remained small, but the individuals and families who have lived in the city, just like those of any community, have been the source of the relationships that have made this city unique.

The city is young enough, at 92 years in 2011, that just a few years ago there lived persons who could remember the early days of ALCOA and Babcock Lumber Company, the first construction of the homes and schools, and the first students to attend those schools and play on their teams. Many of those memories and stories were collected and preserved in 1994, when the city celebrated its 75th anniversary.

The persons who lived here and raised families also conducted the city's church services, led Scout troops, taught school classes, coached teams, and set the example for charitable service to one's fellow man.

A charitable community spirit has been strong in Alcoa, from World War I when ALCOA workers raised money to help provide for French children orphaned in the war, to the establishment of civic clubs and the organization of youth sports leagues, to the company's role in establishment of the United Fund.

From John T. Arter—a strong community leader who strove for better pay, schools and transportation for African American residents— in the Hall community to Garnet Manges and Dorothy Dockter—who taught piano lessons to Alcoa's youth—to legendary coaches Bill Bailey, Vernon Osborne, and Clarence Teeter, these are the persons without whom life in Alcoa would not have been possible.

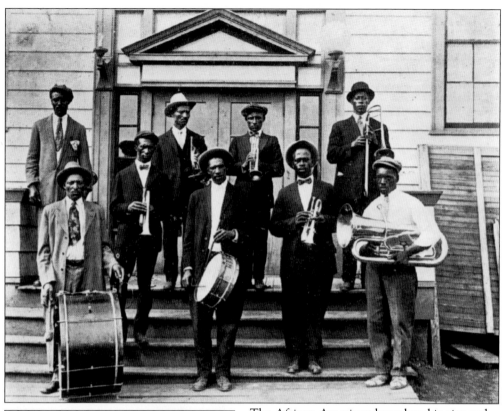

The African American brass band is pictured in 1919 on the front steps of the Community Building in the Hall community. Shown from left to right are (first row) Dan Townsend, Charles Hodson, Fred Davenport, Henry Pinstone, and Will Brown; (second row) James Jones, Rex Cansler, Henry Jefferson, and Walter Patton. The building featured a recreation hall and auditorium, where movies were shown and dances and other events held. The building also served as a gymnasium for Hall High School until 1951. (Courtesy of Alcoa, Inc.)

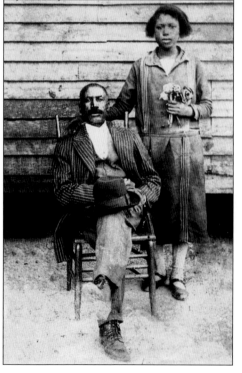

Pictured are Amos Strickland and his wife, Reese Strickland, around 1930. (Courtesy of Diane Strickland.)

At right is a picture of the Hultquist family in front of their home on Springbrook Road. From left to right are Charlotta Hultquist Healy (Alcoa High School class of 1928), Virginia Hultquist Guess (Alcoa High School class of 1926), Jerome "Jerry" Hultquist (Alcoa High School class of 1934), Charles Hultquist (Alcoa High School class of 1937), and parents Lola and V.J. Hultquist. The picture was taken around 1925. Below, the family is shown around 1930. From left to right are (first row) Lola, Charlotta, and V.J.; (second row) Jerome, Virginia, and Charles. (Both courtesy of Kathy Overholser.)

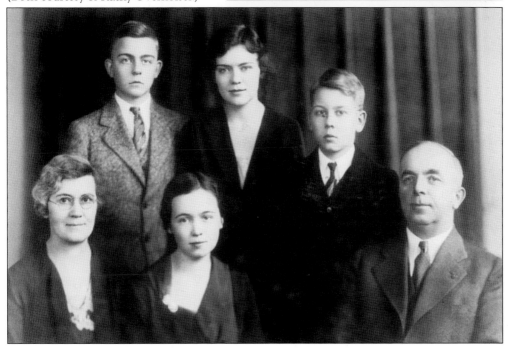

John Henry Kidd and his wife, Nannie Jane Matthews Kidd, are shown in Springbrook Park around 1929. The Kidds were the grandparents of former Alcoa City commissioner Ralph Kidd. (Courtesy of Ron Kidd.)

Garnet Manges was valedictorian of her 1926 Alcoa High School class. She is pictured in front of the family home on Poplar Street, one of the Babcock-constructed homes. She obtained a master of arts degree from Columbia University and taught music to local students. (Courtesy of Col. Duff "Zoe" Manges.)

Barbara Paine Stone and Doris McPherson, piano students of Garnet Manges, gave a recital at the Chilhowee Club in the late 1940s. At the reception afterwards are, from left to right, Kathryn Paine McConnell, Charlsie Spencer Wright, Elenor Grubb, Evelyn Paine, Peggy Cate Smith, unidentified, Joyce Linginfelter Hughes, Rebecca Derrick, Patsy Cate Varth, and Marline Pine Alton. (Courtesy of Col. Duff "Zoe" Manges.)

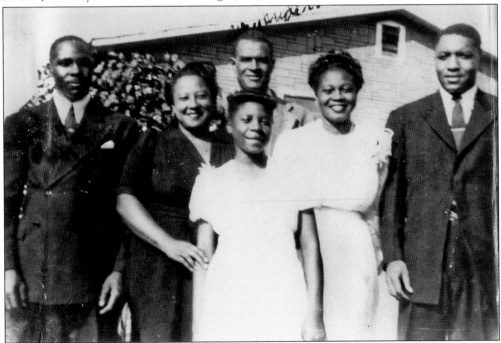

The Henderson family is pictured around 1940. From left to right are Fred McGarity, Mamie McGarity, Mildred Henderson Swann (front), Worth Henderson, Freddie Mae Henderson, and Cecil Henderson. Swann is the mother of NFL Hall of Fame member Lynn Swann. (Courtesy of Cecil Henderson.)

Shown second and fourth from left are Helen Warden Beightol and her husband, Harry Beightol, progenitors of Alcoa's Beightol family. Also pictured are, at left, daughter Velma Beightol Holliday (Alcoa High School class of 1927) and Henry Holliday. Other Beightol children were Charles (Alcoa High School class of 1926), Harold, Richard, Evelyn, Vernon, and Betty (Alcoa High School class of 1940). It is believed that the first Roman Catholic masses in Alcoa were said at the Beightol home on Poplar Street. (Courtesy of Marsha Ware Brown.)

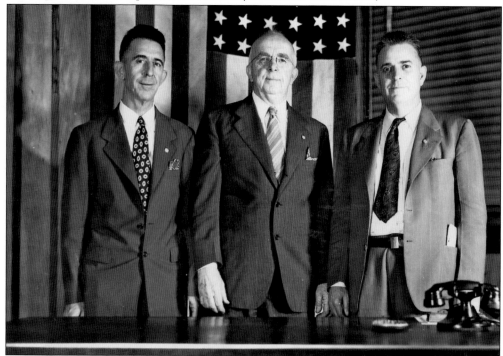

From left to right are early city officials A.B. Smith, city recorder (later city manager); V.J. Hultquist, city manager; and Homer A. "Bully" Goddard, city attorney. (Courtesy of Alcoa High School Alumni Association.)

Mae Burns Kolbe, pictured in May 1938, taught third grade at Bassel School. (Courtesy of Freda McCulloch.)

Shown are Dossie F. Bledsoe and his wife, Anna Mae Bledsoe, progenitors of Alcoa's Bledsoe family. Their children were Don, Tim, Connie, Myrna, Mahlon, Jerry, Clayton, Karen, Gary, and Loren. (Courtesy of Don Bledsoe.)

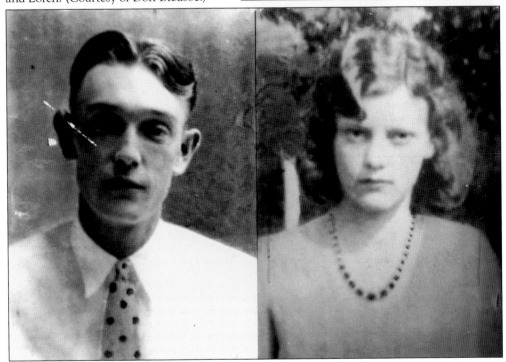

Pvt. James G. Dobson is shown upon his return home in 1953 after having been held as a prisoner of war by North Korean communists since February 1951. (Courtesy of Wanda Dobson.)

Blanche Belle "Gransy" Manges is at her receptionist desk at the ALCOA West Plant office building. She was a 50-year Sunday school teacher at Alcoa First United Methodist Church and was the founding organizer of the first parent-teacher association (PTA) in Blount County. (Courtesy of Col. Duff "Zoe" Manges.)

Members of the Home Demonstration Club are pictured around 1940. From left to right are Dollie Siler, Odessa Carr, Epie Julian, and Dorothy Strickland. (Courtesy of Diane Strickland.)

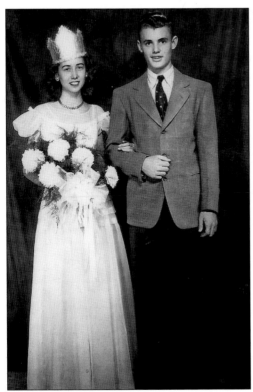

Pictured in 1946 are Pauline Law and Ralph Dover, Alcoa High School's football queen and attendant. (Courtesy of Alcoa High School Alumni Association.)

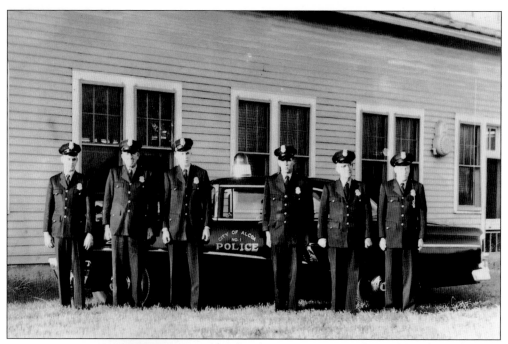

Alcoa's policemen are pictured in 1956 at the Mule Barn. From left to right are Bill Hunt, S.N. Lands, Dillard Satterfield, Charles Hunt, Sam Williams, and Charles Sherrod. Arthur Lively, not shown, was still chief of police at the time. (Courtesy of Sue Capps Satterfield.)

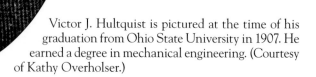

Victor J. Hultquist is pictured at the time of his graduation from Ohio State University in 1907. He earned a degree in mechanical engineering. (Courtesy of Kathy Overholser.)

Duff Gerard Manges came to what would become Alcoa in 1918 as woods foreman and second in command at Babcock Lumber Company's Vose operations. (Courtesy of Col. Duff "Zoe" Manges.)

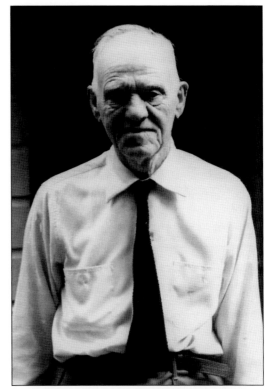

Jean Baumann (below, left) obtained flight training for a pilot's license before she was old enough for a driver's license. She was chosen as queen of the East Tennessee Flyers Club in 1945 and is shown here around 1951, when she was serving in the US Air Force. Col. Duff "Zoe" Manges (below, right) is pictured as a West Point plebe. He graduated from Alcoa High School in 1954 and is believed to be the first Alcoa boy to attend West Point. He holds the record for the most points scored in a basketball game in the Springbrook gymnasium (39), against Townsend in 1954, the last full season high school games were played there. (Left, courtesy of Jean Baumann; right, courtesy of Col. Duff "Zoe" Manges.)

James A. Clodfelter was city recorder from 1957 to 1968. He later served as law librarian at the University of Tennessee and then as legislative attorney for the legislative council committee of the Tennessee General Assembly. From 1977 to 1999, he was director of the Office of Legal Services for the General Assembly and executive secretary of the Tennessee Code Commission. (Courtesy of James A. Clodfelter.)

Alcoa's Cub Scout Pack 85 attended the University of Tennessee versus Wofford football game at Neyland Stadium in October 1952. Shown are (middle of the first row) Steve Frankum; (second row, left to right) Steve Fritschle, Bill Ostendorf, Curtis Myers, and Dick Guldi. The other boys are unidentified. (Courtesy of Dick Guldi.)

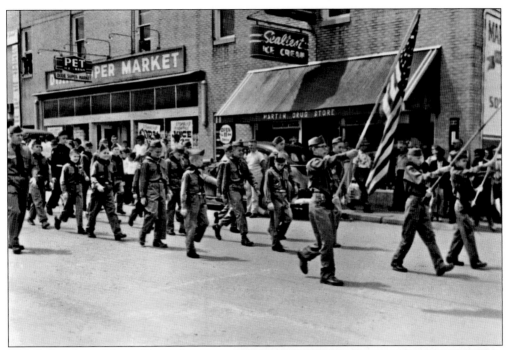

Alcoa's Boy Scout Troop 85 marches on Broadway in this picture taken in 1955. Scoutmaster Lonnie West is at left. (Courtesy of Dick Guldi.)

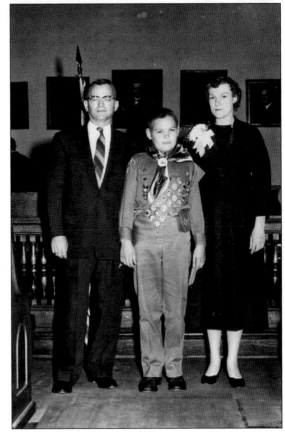

Jim Creswell, center, receives his Eagle Scout award in the old circuit courtroom at the Blount County Courthouse in October 1956. With him are his parents, Wallace and Minnie Creswell. (Courtesy of Dick Guldi.)

Shown are Jack Rector, left, and longtime Boy Scout Troop 85 Scoutmaster Lonnie West. They are standing at the altar rail inside Alcoa First United Methodist Church. The church has sponsored Troop 85 for many years. (Courtesy of Dick Guldi.)

Alcoa Girl Scout Troop 215's members are pictured around 1960. From left to right are (first row) Beverly Clark, Pat Hendricks, and Betsy Peeden; (second row) Carol Milton, Patsy Hoover, Jane Cook, Susan Guldi, Margaret Salo, Susan Clarke, and Ann Salo. The leader is unidentified. (Courtesy of Dick Guldi.)

Andrew Carr performs in the late 1940s. A former teacher at Hall High School, Carr taught and performed across the United States, singing Negro spirituals, gospel, and classical music. (Courtesy of Diane Strickland.)

Bill Dockter, left, and his father, Albert Dockter Jr., are pictured removing clinkers (coal residue) from the coal furnace of their Poplar Street home in 1958. (Courtesy of Bill Dockter.)

Former mayor O.W. Brumfiel is pictured at his First Federal Savings and Loan retirement celebration around 1959. He had retired from ALCOA in 1944. Brumfiel served as Alcoa's mayor from 1943 to 1965. From left to right are granddaughter Virginia Hand Campbell, Robert Hand, L.A. Campbell, wife Mildred H. Brumfiel, Mayor Brumfiel, Carl Loflin, and daughter Harriet Loflin. (Courtesy of Virginia Campbell.)

Pictured at a Home Demonstration Club meeting in 1962 are, from left to right, Mildred Howard, Susie Hampton, Agnes Watson, Dorothy Strickland, and Deloris Bomar. (Courtesy of Diane Strickland.)

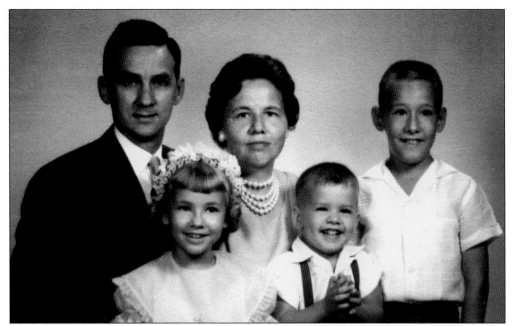

The Widner family is pictured around 1960. From left to right are John, Beth, Nelle, David, and Steve. John served the city as a commissioner and vice mayor, and Nelle was a teacher. Each of the children was valedictorian of his or her class at Alcoa High School: Steve in 1969, Beth in 1972, and David in 1977. (Courtesy of Steve Widner.)

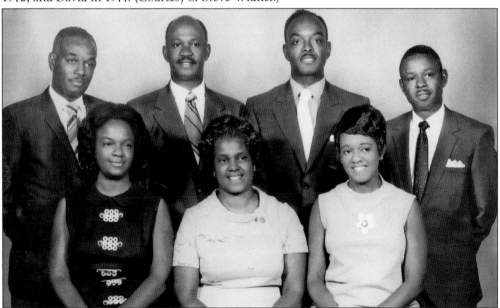

The Carr family, pictured in the early 1960s, is, from left to right, (first row) Patricia Carr Watkins, Mary Ruth Carr White, and Shirley Carr-Clowney; (second row) J.D. Carr, Andrew Carr, Stone Carr, and Jack Carr. Shirley Carr-Clowney was one of the first three African American females to attend Maryville College, the other students being Queen E. Crossing and Louise Hill Gilmore. Stone Carr was Alcoa's first African American commissioner, elected in 1968. (Courtesy of Shirley Carr-Clowney; photograph by Frank and Mary Clark.)

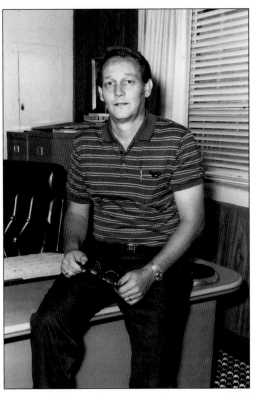

Don Bledsoe was Alcoa's fire chief from 1965 to 1966. He supervised the water department from 1960 to 1965, and he later served as public works director from 1967 to 1990. He hired each of the four fire chiefs who succeeded him. (Courtesy of Don Bledsoe.)

Congressman John J. Duncan Sr., left, and John Wilson are pictured in the 1970s. Wilson was a longtime youth athletics coach in the city. (Courtesy of George Williams.)

Seven

FAITH

ALCOA also understood the importance of faith in the life of the community. The company leased lots to three church congregations, then loaned money for construction of the church buildings. The company, thus, was instrumental in the establishment of Calvary Baptist Church and St. Paul African Methodist Episcopal Church in 1921, as well as the establishment of the Methodist church in the Springbrook community in 1922. In 1923, the company completed the brick veneer on these buildings.

Alcoa First Baptist Church, originally known as Fairview Baptist Church, was organized in 1912 with nine members. The congregation initially met in the Green School on Birch Street. The current location of the church was donated by Myrtle Dougherty. In 1920, a new, wooden frame church was built. In 1939, a new sanctuary was constructed, and it served the congregation until the present sanctuary was built in 1964.

While most of the city residents were affiliated with the Baptist and Methodist faiths, Roman Catholic Masses were said at the home of Harry and Helen Beightol on Poplar Street. Our Lady of Fatima Church, which previously was located in Maryville, constructed its new building in Alcoa in 1952. Our Lady also opened a school in 1955.

Other churches have included St. John Baptist in Oldfield, Bethel Baptist and Rest Haven Baptist in Hall, Central Baptist in Springbrook, and East Alcoa Baptist in the Rock Gardens community.

The churches of Alcoa have served the community in many respects. For example, Alcoa First Methodist, for a long time, was home to a Girl Scout troop and still sponsors Boy Scout Troop 85. The Methodist Women organization prepared weekly meals for the Alcoa Rotary Club for many years.

Churches have been at the center of community life from the inception of the city.

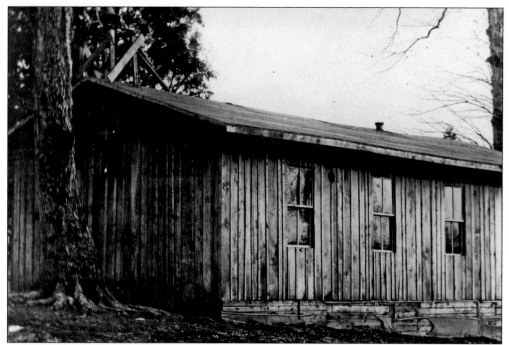

According to ALCOA's records, this building is believed to have been Alcoa's first African American Baptist church. It was located on Americus Avenue, and it is shown here in 1918. This building was also one of the two small houses used for the African American school; it contained the beginner and primary classrooms. (Courtesy of City of Alcoa.)

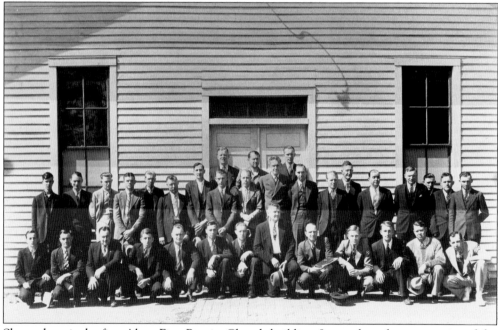

Shown here is the first Alcoa First Baptist Church building. Located on the present site of the church, this wood frame structure was built in 1920, and a church men's group is pictured in 1938. (Courtesy of Alcoa First Baptist Church.)

The Methodist church in the Springbrook community began meeting in this old farmhouse, known as the Daugherty house, in December 1920. The first pastor was Rev. Sidney Stringham. Charter members were Mrs. W.T. Bates, O.W. and Mildred Brumfiel, J.M. and Sally Fox, and Henry D. Helton. (Courtesy of Alcoa First United Methodist Church.)

The first Methodist church, constructed in 1922, was used as a parsonage after construction of a new building in 1948. ALCOA donated the property for the church in 1922 and loaned the money for church construction. (Courtesy of Alcoa First United Methodist Church.)

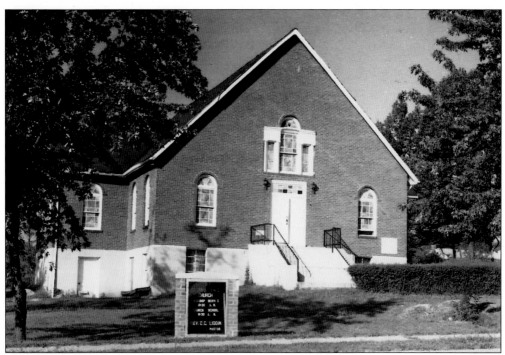

St. Paul African Methodist Episcopal (A.M.E.) Church was one of three churches for which ALCOA donated property and loaned money for construction. St. Paul was established in 1921. (Courtesy of City of Alcoa.)

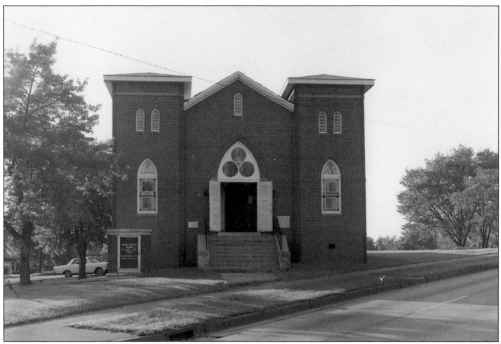

Bethel Baptist Church, located on Hall Road, is shown around 1969. Its open doors invite the community to join this long-established congregation in worship. (Courtesy of City of Alcoa.)

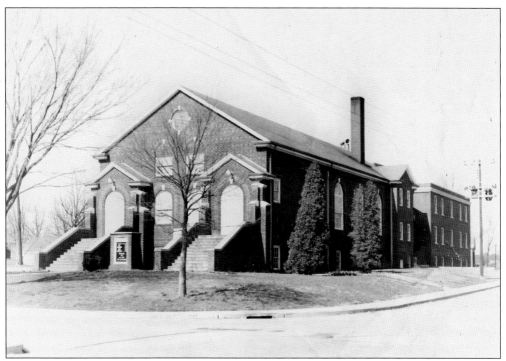

First Baptist Church of Alcoa opened this new building in 1939. The educational building to the rear of this photograph has been retained on the site and was incorporated into the new church, which was opened in 1964. (Courtesy of Cliff Stubblefield and Alcoa First Baptist Church.)

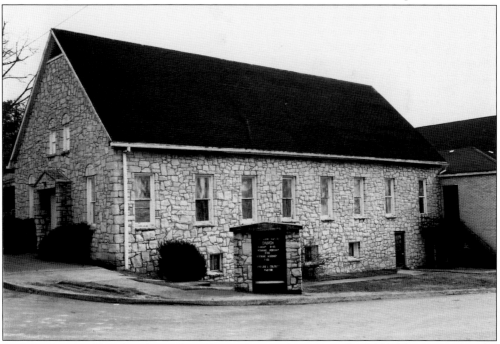

St. John Baptist Church is located on Bessie Harvey Avenue in the Oldfield community. The street is named for folk artist and minister Bessie Harvey. (Courtesy of City of Alcoa.)

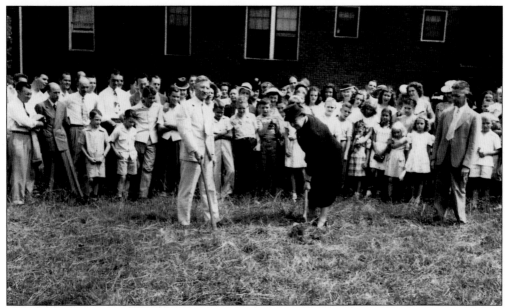

Shown here is the ground-breaking ceremony for the new Methodist church building completed in 1948. Prior to this construction, the congregation met in the house in the background, which became a parsonage. With shovels in hand are Mayor O.W. Brumfiel, left, and Blanche Manges. (Courtesy of Col. Duff "Zoe" Manges.)

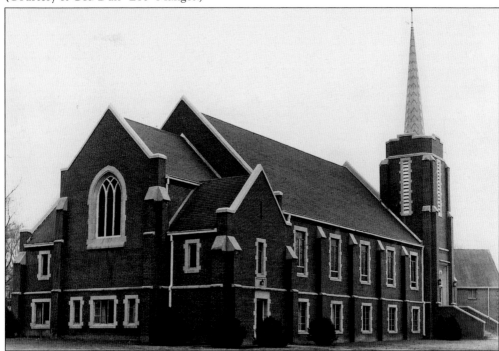

Alcoa First United Methodist Church's new 1957 building is shown here. In the late 1930s and 1940s, the city would occasionally close a portion of Darwin Street between the church property and Springbrook Park to provide an area for youth roller-skating. (Courtesy of Alcoa First United Methodist Church.)

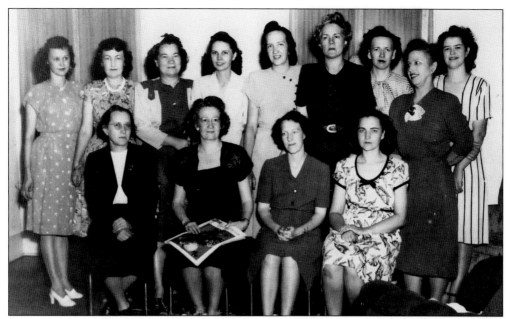

Pictured around 1946 is Alcoa First United Methodist's Wesleyan Service Guild. Shown from left to right are (first row) Ruth Griffitts, Thelma Hardin, Mary Keller Kizer, and Nannie B. Murrell; (second row) Ann Miller, Marie Foster, Hazel Fox, Edith Fox, Frankie B. Hendricks, Mrs. Joe Hardin, Reba Alexander, Mattie Lingerfelt, and Bernice Key. (Courtesy of Alcoa First United Methodist Church.)

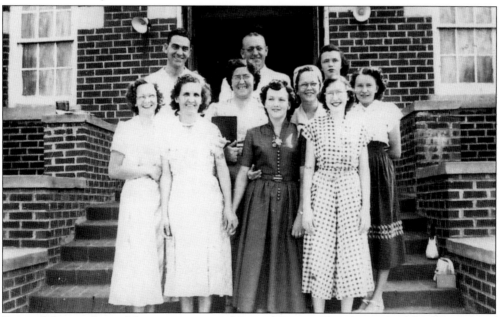

Some of the members of the congregation of Central Baptist Church stand on the front steps of the original church building around 1950. From left to right are (first row) unidentified, ? Allen, Mable Keller, and Freda Headrick McCulloch; (second row) unidentified, ? Spence, and ? Webb; (third row) unidentified, Rev. Paul Watson, and Ann Nell Clifton. The original building was destroyed by fire in 1959. (Courtesy of Freda McCulloch.)

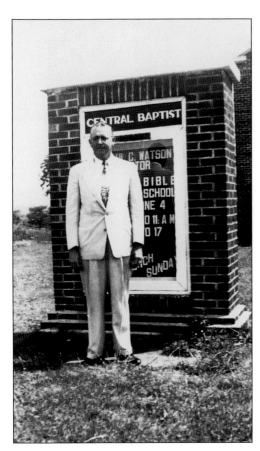

Rev. Paul Watson, pastor of Central Baptist Church, is shown here around 1950. (Courtesy of Freda McCulloch.)

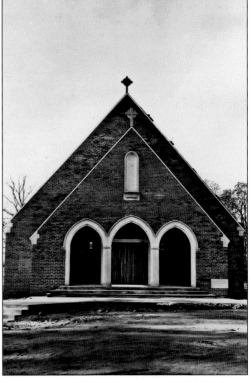

Our Lady of Fatima Roman Catholic Church opened this building in Alcoa in 1952. The first pastor in the new building was Rev. Paul W. Clunan, who served the parish from 1950 to 1957. (Courtesy of Our Lady of Fatima Church.)

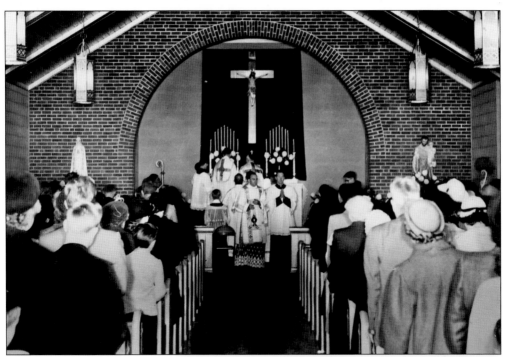

Bishop William Adrian of the Nashville Diocese led the Dedication Mass of Our Lady of Fatima Church on December 6, 1952. The service is pictured here. (Courtesy of Our Lady of Fatima Church.)

From left to right are Barbara Cunningham Godfrey, Linda Cunningham Reed, and Dee Ann Cunningham Mendel. The sisters sang "Tonight You Belong to Me" to Fr. Paul Clunan in honor of his feast day at Our Lady of Fatima School around 1956. (Courtesy of Our Lady of Fatima Church.)

www.arcadiapublishing.com

Discover books about the town where you grew up, the cities where your friends and families live, the town where your parents met, or even that retirement spot you've been dreaming about. Our Web site provides history lovers with exclusive deals, advanced notification about new titles, e-mail alerts of author events, and much more.

MADE IN THE USA

Arcadia Publishing, the leading local history publisher in the United States, is committed to making history accessible and meaningful through publishing books that celebrate and preserve the heritage of America's people and places. Consistent with our mission to preserve history on a local level, this book was printed in South Carolina on American-made paper and manufactured entirely in the United States.

This book carries the accredited Forest Stewardship Council (FSC) label and is printed on 100 percent FSC-certified paper. Products carrying the FSC label are independently certified to assure consumers that they come from forests that are managed to meet the social, economic, and ecological needs of present and future generations.

FSC
Mixed Sources
Product group from well-managed forests and other controlled sources

Cert no. SW-COC-001530
www.fsc.org
© 1996 Forest Stewardship Council

Find Your Place in History.